LOST
YOUNGSTOWN

LOST
YOUNGSTOWN

SEAN T. POSEY

Published by The History Press
Charleston, SC
www.historypress.net

Copyright © 2016 by Sean T. Posey
All rights reserved

Front cover: Courtesy of Mark Reyko.

First published 2016

Manufactured in the United States

ISBN 978.1.62619.832.6

Library of Congress Control Number: 2015956824

Notice: The information in this book is true and complete to the best of our knowledge. It is offered without guarantee on the part of the author or The History Press. The author and The History Press disclaim all liability in connection with the use of this book.

All rights reserved. No part of this book may be reproduced or transmitted in any form whatsoever without prior written permission from the publisher except in the case of brief quotations embodied in critical articles and reviews.

This book is dedicated to the memory of Brother Todd Ridder.

CONTENTS

Acknowledgements 9
Introduction: The Biggest Little City on Earth 11

PART I: INDUSTRIAL COLOSSUS
1. Youngstown Sheet and Tube 19
2. Republic Rubber 39

PART II: THIRD PLACES
3. The Liberty/Paramount Theater 59
4. Uptown 80
5. The (Nu) Elms Ballroom 99
6. The Newport Theater 114

PART III: COMMUNITIES OF THE PAST
7. From Monkey's Nest to Brier Hill: A Trip Down Old West Federal 125
8. Smoky Hollow 145

Notes 155
Bibliography 163
Index 169
About the Author 175

ACKNOWLEDGEMENTS

Any book of this kind is the product of much hard work and the kindness of strangers, friends and colleagues. I would like to thank my mother and father for their boundless support and for sharing their memories of Youngstown with me as a young man. I would also like to thank Bryan Ridder for all of his support. The reference librarians of the Youngstown Public Library, especially Sally Freaney, assisted me greatly in tracking down rare historical references. Their work proved invaluable to this project. I would like to thank local historians Mark Peyko and Thomas Welsh for their advice and time. The archivists at the Youngstown State University Archives and Special Collections, especially Lisa Marie Garofali, also deserve my special thanks.

Stacey Adger provided initial inspiration for my journey into the history of Monkey's Nest. Father Joseph Rudjak graciously pointed me in the direction of several interviewees who once lived in Monkey's Nest. Joseph J. Cassese, Ron Flaviano, Mark Hackett, Ken Kovalchik, Thomas Molocea, Mark Peyko, Anna Marie Quaranta, Mike Roncone and Gerryanne Thomas provided additional private images. Videographer Ron Flaviano's work proved invaluable for the book's promotion.

I would also like to thank the many interviewees who very generously donated their time and shared their memories with me. Interviewees included Martel Davis Allen, Donald Attenberger, Kelly Bancroft, Rebecca Banks, Robert Bigelow, Joseph J. Cassese, Jeff Chrystal, Sister Jerome Corcoran, Bill DeCicco, Bruce Dill, Guy DiPasqua, Irene Economou, Ron

ACKNOWLEDGEMENTS

Flaviano, Bill George, Todd Hancock, Don Hanni III, Patrick Kerrigan, Bill Kovalchik, Alan Kretzer, Ben Lariccia, Joe "Ting" Markulin, Tonya Martin, Harry Meshel, James Moore, Liz Moore, Edo Pacic, Nadine Parker, Mark Peyko, Jeff Pillot, Jerry Poindexter, Fred Posey, Anna Marie Quaranta, Tom Ramos, Cathy Reuter, Patrick Ridder, Mike Roncone, Father Joseph S. Rudjak, Clayton Ruminski, Richard Scarsella, Del Sinchak, Frances Prayor Singleton, Betty Peters Soni, Helen Tatarka, Gerryanne Thomas, Bill Umbel, Bob Vargo and Rob Zellers.

Introduction

THE BIGGEST LITTLE CITY ON EARTH

At the beginning of the nineteenth century, brothers Daniel and James Heaton discovered bog ore in Yellow Creek, near Youngstown, Ohio. Not long after, they began construction of the Hopewell Furnace, the first iron-producing furnace in the country west of the Allegheny Mountains.[1] Early primitive furnaces, made of stone and powered by charcoal, supplied the first simple iron products in Mahoning County. By the turn of the nineteenth century, the manufacturing city of Youngstown had gone from a rustic village in the wilderness of the Northwest Territory to a growing manufacturing center known for high-grade coal and the production of iron. Dubbed "the biggest little city on earth," Youngstown symbolized the enormous growth of the American Midwest's industrial might. Three short decades later, Youngstown was the forty-fifth-largest city in the country, standing at the heart of one of the world's largest steel districts. Upon coming to the area in 1939, First Lady Eleanor Roosevelt wrote of her impressions of the burgeoning industrial city:

> *There is a certain majesty to this industry which catches one's imagination. We came out from a street to find ourselves looking down over what seemed to be an almost limitless array of factory buildings and chimneys. The driver of our car said "That is the U.S. Steel Company and it covers six miles." Think of the investment represented and of the stake which the people working here have in the success or failure of that business, not to mention the innumerable people who own a part of the invested capital.*

INTRODUCTION

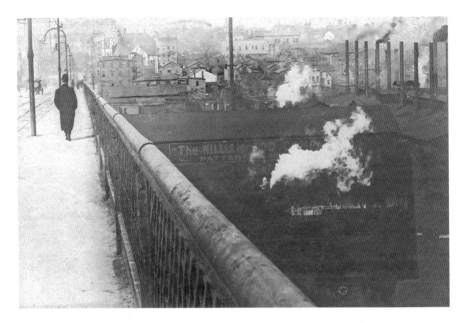

A solitary individual walks across the smoky Market Street Viaduct, circa early 1900s. *Courtesy of Thomas Molocea.*

It takes your breath away to think that human beings are responsible for anything so vast and far-reaching.[2]

For miles up and down the Mahoning River, the massive mills of the Mahoning Valley stood like a wall. Inside these mini-cities, an almost otherworldly drama played out on a daily basis: men, machines, smoke and fire served as the cast of characters in a spectacle of steelmaking. At night, the hills of slag along the river glowed with a fiery heat; the Mahoning River itself, used by the mills to cool steel, never froze—even during the coldest months of winter. Youngstown Sheet and Tube, Republic Steel (also founded in Youngstown), U.S. Steel and Sharon Steel all had facilities in the area. Outside of steel, manufacturing companies like Republic Rubber produced everything from rubber hosing to golf balls. Youngstown symbolized industrial America itself. In 1950, the city produced "more steel per square mile or per capita than any similar spot on earth."[3] And beyond the wall of metal and machines, the city's cultural life thrived.

The area's steel mills drew thousands of migrants from the South and European immigrants looking for a new life in a new world. They built vibrant ethnic neighborhoods, businesses and cultural institutions along the

INTRODUCTION

city's bricked streets. Every language from Louisiana Creole to Croatian could be heard in the corner grocery stores, churches and neighborhoods with famously evocative names like "Smoky Hollow" and "Monkey's Nest." The Keith-Albee vaudeville circuit made Youngstown a prime stopping point in the early twentieth century. Ethel Barrymore, Katharine Hepburn, Joe E. Lewis and other legendary performers graced local stages.

Famed architects like Albert Kahn and C. Howard Crane designed the Stambaugh Building and the Liberty Theater, respectively, for the classically inspired downtown. Upward of fifty thousand shoppers would crowd downtown on cold holiday nights during Christmas shopping season in the 1940s. During World War II, men and women manned the blast furnaces and rolling mills of wartime industry, and they danced the night away to the sounds of Duke Ellington and Frank Sinatra at places like the Nu Elms Ballroom. Theater patrons took in the latest Humphrey Bogart or Bette Davis film at the ornate Paramount Theater. Diners, dressed to the nines, enjoyed topflight meals at places like the Colonial House in the vibrant Uptown district. At the same time, labor clashes, Harry Truman's efforts to seize the city's steel mills and the machinations of the Mafia made Youngstown both famous and infamous in the national imagination.

Youngstown represented the crossroads of the Midwest. The city's central location between Chicago and New York and between Cleveland and Pittsburgh made it a crucial stopping point for everything from the country's big bands and rock acts to railroads and over-the-road shipping concerns. The organized crime families of the Midwest coveted the rackets of Youngstown and fought over them voraciously. In an era when Ohio's industrial economy and its "Big Eight" cities dominated the industrial heartland, Youngstown represented a mecca for many.

A dark morning in September 1977 changed everything. On a day forever known locally as "Black Monday," the Youngstown Sheet and Tube Company announced the closure of its steel works in the nearby city of Campbell. The fallout from Black Monday and the ensuing mill shutdowns—along with the continued legacy of suburbanization and urban renewal—erased many of the city's landmarks: mills crumbled into ruin, neighborhoods vanished under the assault of bulldozers and many of the bustling corridors of commerce fell silent. During the 1960s alone, Youngstown lost 16 percent of its population—more than Gary, Detroit, Flint, Chicago or other industrial cities. The city's population dropped even further after the mill closings, from a high of 170,000 in 1930 to only 115,000 in 1980. Unemployed steelworkers murmured that Youngstown seemed destined to go from a steel

INTRODUCTION

town to a ghost town. In an era that gave birth to the term "Rust Belt," Youngstown served as the buckle.

While Youngstown and other once prosperous cities faced declining prospects in the 1960s and 1970s, a photographer named Camilo José Vergara began documenting America's hard-pressed urban centers. Vergara photographed and re-photographed structures and buildings as they passed into decay or as they were repurposed for new and often surprising uses. For the next several decades he chronicled an ever-changing urban landscape with a simple premise:

> *I feel that a people's past, including their accomplishments, aspirations and failures, are reflected less in the faces of those who live in these neighborhoods than in the material, built environment in which they move and modify over time. Photography for me is a tool for continuously asking questions, for understanding the spirit of a place, and as I have discovered over time, for loving and appreciating cities.*[4]

In the 1990s, a group of people who came to be known informally as "urban explorers" started documenting the detritus of industry and distressed cities through underground publications, books and photography. Explorers like Jeff Chapman and others in Toronto helped popularize this underground pastime, and "urbex," for short, began spreading from Canada into America. Many of the abandoned office buildings, factories and movie theaters of the Rust Belt now play host to urban explorers—a group of mostly young people born long after the heyday of industry—who comb through these lost places, cameras in hand, seeking adventure and a brief glimpse into storied histories.

This is how I came to understand many of the important places of Youngstown's past—by first putting a camera to my eye and capturing a long-forgotten building or a parking lot that miraculously, to my mind, was once a dance hall or an Art Deco movie theater. In the spirit of Vergara and the photographers who came after, this book attempts to combine historical photographs with contemporary images of abandoned places and urban landscapes altered by the vicissitudes of time.

The hurried footfalls of students and the strident sound of a stiff spring breeze echo past the Kilcawley Center on the campus of Youngstown State University nestled next to the heart of downtown. There is nothing to suggest that what is now campus was once a densely populated neighborhood. But at one time, the country's biggest musical acts pulled down Elm Street to one

INTRODUCTION

of the finest dance halls in Ohio. On the city's south side, a Burger King now stands at a commercial corridor that once housed a notable neighborhood theater. Fast-food patrons and cars pulling into the drive-through have replaced the throngs of children waiting in line with a dime for the Saturday shows at the Newport Theater. On the lower east side of the city, only broken buildings and the long-silent stacks of Republic Rubber are left to stand as a testament to the thousands who once toiled there.

The histories of sites like these, situated in the urban landscape of any given city, are often bereft of images that capture the changing built environment. And the built environment helps situate memories of the past, allowing us to further understand a community's history. The field of modern historical preservation in America roared to life popularly in the wake of the destruction of Penn Station in New York in 1963. However, the central role that other historical structures (not designed by famous architects) play in the role of community memory is not nearly as appreciated. Other more common historical sites, such as schools, neighborhoods, dance halls and community centers, also "have the power to evoke visual social memory."[5]

The history presented here encompasses examples from most of the facets of life in Youngstown: industry, neighborhoods and "third places," or communal sites outside of both work and home. A combination of archival research, oral histories and interviews with a diverse group of both current and former Youngstown residents provide the backbone of the book.

Part I, "Industrial Colossus," covers two companies that perfectly symbolize the city's industrial past: Youngstown Sheet and Tube and Republic Rubber. Part II, "Third Places," examines the history of the city's last great motion picture house, the Paramount Theater, and the history of the fabled Uptown district. Also included are the fabulous Elms Ballroom, once one of the top dancing destinations in northeast Ohio, and the Newport Theater, perhaps the finest of the old neighborhood movie theaters. Part III, "Communities of the Past," explores vanished immigrant neighborhoods—Monkey's Nest and Smoky Hollow—and the old West Federal corridor leading to the neighborhood of Brier Hill. These places represented the incredibly diverse working-class districts that gave Youngstown a reputation as a melting pot of cultures.

Today, the biggest little city on earth is better known as "the incredible shrinking city." The decline of the local steel industry and the movement of the population to the suburbs dramatically altered the landscape, and many of Youngstown's landmarks exist now only on film and in memory. However, a recent renaissance in the long-dormant downtown is slowly reviving and

INTRODUCTION

reactivating some of Youngstown's oldest and most noted commercial buildings. A new generation is coming to appreciate the history and the built environment of Youngstown. But as the city looks forward, it is important to remember the once vaunted establishments and communities of the past. For even though they have long since vanished from the landscape, their legacy lives on.

PART I
INDUSTRIAL COLOSSUS

1
YOUNGSTOWN SHEET AND TUBE

For nearly eighty years, the Youngstown Sheet and Tube Company remained the central business institution in Youngstown. Known as "the boss," Sheet and Tube exerted an outsized influence on the community. Unlike the other steel giants in the area, the company bore the Youngstown name. When literature, advertisements and products went out, they were stamped with the emblem "Quality Youngstown Service." Formed locally in the early twentieth century, the company gradually expanded to become the fifth-largest steel company in the nation. Sheet and Tube became the centerpiece of the largest merger drama in the history of the steel industry, and it captured the attention of the nation's highest court when Harry Truman seized the mills during the Korean War. The closing of Sheet and Tube's Campbell Works in 1977 represented the largest peacetime plant shutdown in American history up to that point; it also marked the beginning of the fall of the nation's large, integrated steel companies.

The Mahoning Valley's nascent iron industry emerged in the early nineteenth century. The Mill Creek Furnace, constructed around 1833, was the first iron furnace to open in Youngstown proper. The Eagle Furnace, located just north of Youngstown, followed in 1846. The ensuing discovery of black coal underneath nearby Brier Hill and the building of the Pennsylvania and Ohio Canal enabled the affordable and efficient movement of the much-sought-after "Brier Hill black" coal and other goods from the area's landlocked location. Mine owners David Tod and Henry Stambaugh used their profits from the mines to invest in and accelerate the growth of the local

iron industry. The coming of the Civil War provided an enormous demand for iron products, and the local iron makers prospered accordingly. Soon, the canal closed in favor of the railroad. As iron furnaces sprang up, workers began coalescing around Brier Hill and other early immigrant communities. Youngstown was a "kingdom in iron," but iron, by the end of the nineteenth century, was rapidly being replaced by steel production.

On November 23, 1900, investors incorporated the Youngstown Iron Sheet and Tube Company. The list of initial stockholders read like a who's who of prominent citizens: Sallie Todd; George, Henry and Charles Wick; John and Henry Stambaugh; and Paul Powers, among others. The company raised funds to purchase land in a fallow area of East Youngstown (the present-day city of Campbell). Four sheet mills were soon constructed, fourteen double-puddling furnaces, three tube mills and a skelp mill.[6] However, Sheet and Tube lacked an adequate process for making steel. Since the first American Bessemer converter began operation in Troy, New York, in the 1860s, steel had been gaining importance in America. Youngstown Sheet and Tube finally built its first Bessemer converter in 1905; for lack of capital funding, open-hearth furnaces remained on the drawing board.

Along with steel's greater tensile strength, the process of making it proved to be far more efficient and cost effective. Iron puddling was a labor-intensive process of creating wrought iron. Puddlers possessed a valuable skill set, and they commonly worked twelve-hour days, seven days a week, in brutal conditions. Puddlers, however, made reasonably good money and were described as the "cocks o' the walk" of early industrial workers in the valley.[7] As the Bessemer process for making steel and then the open-hearth process expanded, the role of iron and the place of puddlers in the industrial hierarchy decreased markedly.

Citing ill health, George Wick resigned as president of the company soon after it formed. An experienced and driven businessman named James Campbell replaced him as president and chairman of the board. Under his leadership Sheet and Tube dropped "iron" from the company name and began aggressively building an infrastructure capable of competing in the rapidly expanding local steel business.

The company's Campbell Works in East Youngstown steadily expanded until it ultimately reached almost five miles in length. Campbell, an experienced manager, maneuvered the business through the challenging early phases of growth. He also understood that the next technological step was to construct open-hearth furnaces, as they proved far superior to the Bessemer converter in all but the time needed to complete the process.

INDUSTRIAL COLOSSUS

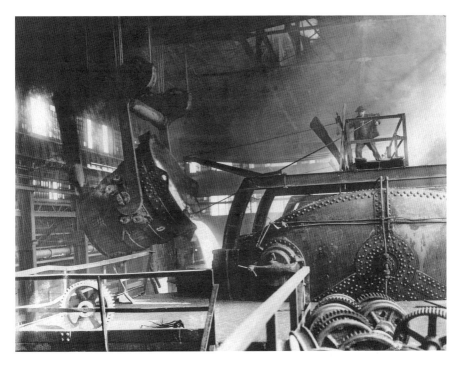

A steelworker labors in the intense heat of a Youngstown Sheet and Tube mill. *Courtesy of Thomas Molocea.*

In 1913, the first open-hearth furnace came online; it joined two existing Bessemer converters. Rapid growth led to rapid employment, and although conditions in the mills largely exceeded those in the old iron companies, problematic living and working conditions led to big clashes between labor and the steel industry.

Youngstown Sheet and Tube unveiled a new emergency hospital in East Youngstown for workers in 1915. The Italian Renaissance–style structure cost nearly $100,000. The company also started a fund to pay for medical expenses for injured workers; however, the hospital really represented a practical step in the direction of "welfare capitalism." Executives understood the brutal nature of millwork, and perhaps more importantly, they feared anything that could give unions a foothold in the workplace.[8] Yet it would take the disastrous events of 1916 before even minimal changes in work and community life began.

The life of early ironworkers was exhausting and routinely dangerous. According to Mahoning Valley iron and steel historian Clayton Ruminski, death and the possibility of being maimed or permanently injured remained

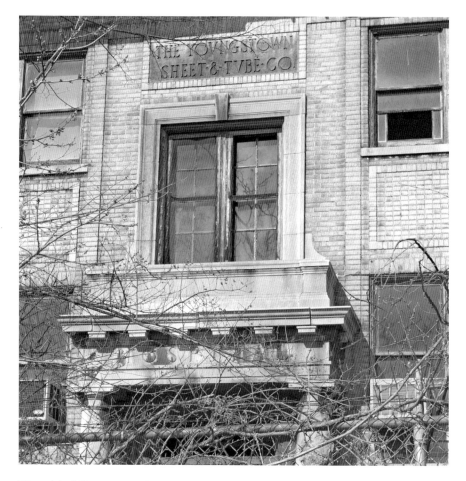

The original Youngstown Sheet and Tube hospital still stands in Campbell, Ohio. *Photo by the author.*

the reality of ironwork.[9] The transition to larger and more efficiently run steel mills lessened those dangers, yet early steelwork was still a life lived in a maze of potential peril in the overwhelming world of the integrated mill. Nor could workers look forward to safe and sanitary conditions in the perpetually overcrowded housing market outside the mills.

Without proper sanitation or paved streets, the hovels of East Youngstown contained a restless population. That restlessness exploded into rage during a strike against Youngstown Sheet and Tube and Republic Iron and Steel in January 1916. An exchange of gunfire between police and strikers resulted in a riot that destroyed four blocks of East Youngstown and resulted in numerous deaths and injuries. The strike itself represented "one of the most

dramatic that the country has ever known."[10] In response to the destruction in East Youngstown, Sheet and Tube moved on several fronts to contain worker frustrations.

The company formed a subsidiary, the Buckeye Land Company, to build worker housing in East Youngstown and the city of Struthers. The result in East Youngstown was forty acres of prefabricated concrete apartments. Both fireproof and well-appointed, they represented the first such units ever constructed.[11] The company's efforts extended to providing opportunities for recreation at company-sponsored events, usually held in Campbell (East Youngstown) or at Idora Park. Dances, baseball teams and enormous Labor Day outings—a rare occasion where management and the rank and file mingled—were designed to assuage worker grievances.

In the workplace, Youngstown Sheet and Tube introduced the *Bulletin* newsletter in 1919. One of the very first of its kind, the *Bulletin* contained a mixture of gossip, industrial news and items intended to publicize the company's efforts to make both work and leisure more pleasant for employees. Despite such efforts, strikes and attempts to unionize the mills continued.

Youngstown Sheet and Tube moved into the 1920s under a cloud of merger rumors. The possibility that the Sheet and Tube name might be

Time and the elements have failed to bring down the original Campbell worker homes, which were the first prefabricated concrete apartments built. *Photo by the author.*

LOST YOUNGSTOWN

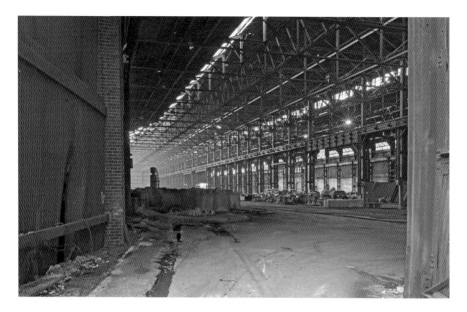

This former Youngstown Sheet and Tube plate mill building, built in 1918, dates back to the original Brier Hill Steel Company. *Photo by the author.*

subsumed in a steel merger filled the local business community with dread. The 1920s only furthered the trend of consolidation in the industry. In 1921, Youngstown Sheet and Tube found itself at the center of a proposed merger with the Brier Hill Steel Company, Inland Steel, Midvale and possibly the massive Bethlehem Steel, among others.

After the proposed merger fell through, James Campbell acquired the Brier Hill Steel Company; part of that company's facilities became the Sheet and Tube Brier Hill Works. More importantly, the company obtained the Steel and Tube Company, which owned valuable properties on Lake Michigan and just outside Chicago. This acquisition was widely viewed as a hedge against what James Campbell and others saw as the future of the industry: midwestern mills situated on large, navigable water routes.

Despite the early concerns over the future of Youngstown's landlocked steel mills, the late 1920s represented a heady era locally. In 1927, the Youngstown district was the largest steel producer in the country, and the city's manufacturing workers earned the highest average wages among similar industrial cities.[12] The population swelled at the end of the decade to over 170,000; the city fathers foresaw a future population of 350,000 or more. But as Youngstown reached new heights, more rumors about a

possible merger between Youngstown Sheet and Tube and Bethlehem Steel, the second-largest producer after U.S. Steel, set the city on edge.

Bethlehem Steel was a major shipbuilder with an aggressive, expansionist outlook, and Bethlehem came to covet Sheet and Tube's Indiana Harbor Works, near Chicago. James Campbell, unlike many in Youngstown, sought the merger with Bethlehem, as he feared for Sheet and Tube's long-term competitive footing. The potential combination drew enormous opprobrium from the public, however. A particularly harsh editorial in the *Youngstown Vindicator* on March 10, 1930, summed up the situation for many: "Youngstown is face to face with the gravest crisis in its history. Upon the solution hangs the future of this city and the Mahoning Valley for all time to come. This is the question: Shall Youngstown remain a first class city, directing its own affairs and master of its own fate, or shall it allow control to slip from its hands and take orders from somebody else for the rest of its life."

The deal ran into further trouble when Cyrus Eaton, a large stockholder, began to rally investors in opposition. Eaton's fortune came from a combination of financial acumen and ruthlessness. Only a few years previous, he orchestrated the formation of the Republic Steel Company, which led to the movement of Republic's corporate headquarters from Youngstown to Cleveland. Still, Eaton understood the importance of maintaining the Youngstown Sheet and Tube name in the Mahoning Valley. He also maintained a visceral dislike for what he considered to be East Coast business elites in the shape of Bethlehem executives. The collapse of the economy and the deepening of the Depression furthered public opposition to what seemed like a deal made by the same type of people who had helped overheat the economy in the first place. A court injunction halted the deal at the end of 1930, and the biggest potential merger in the history of American steel went up like so much smoke from the mill.

The first years of the Great Depression proved as disastrous for Sheet and Tube as they did for the city. Operations were reduced to less than 25 percent of total capacity, and the seemingly perpetually sullen skies around the mills were suddenly clear. Youngstown gained notoriety nationally as "the hungry city," and the local government wrestled with how to handle the ever-growing number of unemployed. In Campbell, (East Youngstown had been renamed after James Campbell in 1922) idle workers spent their hours tending "Depression Gardens." Sheet and Tube maintained over one hundred acres for families to work; every acre held about eight gardens. At least three thousand workers tended such plots during the 1930s.[13]

LOST YOUNGSTOWN

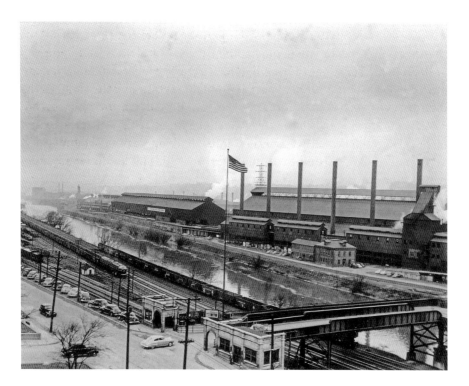

Stop 14 in Struthers, Ohio. *Courtesy of Thomas Molocea.*

While events became increasingly desperate outside, inside the executive offices of Sheet and Tube, management conceived of a daring capital investment. The company already played a major role in the production of pipe. Yet the market for steel sheet, used in manufacturing automobiles, looked like the next sure bet—at least before the Depression. After James Campbell retired in 1930, Frank Purnell became the company's third president. He believed Sheet and Tube should modernize, even if the foreseeable economic climate seemed to rule out such investments. An experimental hot strip mill and new cold rolling mill capacity came online in Campbell during the Depression. Construction of a new seamless pipe mill in 1938 helped solidify Youngstown Sheet and Tube as the second-largest producer of pipe in the nation.[14] But the late 1930s also brought renewed tensions between labor and management.

In 1935, Youngstown Sheet and Tube became the second steel company in the country to offer paid vacations to rank-and-file workers with ten years of service or more.[15] Perhaps it represented another effort to appeal to workers who continued to flirt with efforts to unionize the company; nevertheless,

laborers across Sheet and Tube's plants joined employees striking against so-called Little Steel companies (mainly Inland, Sheet and Tube and Republic) in 1937. At the beginning of March, U.S. Steel, after facing sustained pressure from the Steelworkers Organizing Committee (SWOC) and the Congress of Industrial Organizations (CIO), agreed to recognize the steelworkers' union. As the largest company in the cartel-like steel business, U.S. Steel regularly set prices that affected all other steel companies. It appeared the same would hold true for the recognition of unions; instead, the Little Steel companies refused to follow U.S. Steel's example and unionize.

Unlike Republic, Sheet and Tube made little effort to keep its mills open during what became known as the Little Steel Strike. On May 29, 1937, the *Pittsburgh Press* reported that Youngstown Sheet and Tube's mills remained locked while Republic Steel attempted to air-drop food to strikebreakers inside its plants in the cities of Warren and Niles. The next day brought news of a mass shooting of steelworkers and their families at Republic Steel in Chicago. Violence came to Youngstown in June when guards at Republic Steel fired on picketers, killing two. Soon afterward, the strike ended in failure for SWOC and the CIO. Sheet and Tube, however, had not resorted to violence, and the company's reputation did not suffer the same tarnishing as Republic's.

While the workingmen of Youngstown took to the streets in support of unionization in the 1930s, the city's steel elite continued its exodus from the area. Most of Youngstown's early working-class neighborhoods sprang up in proximity to the mills. Youngstown's iron and steel barons, however, tended to cluster around Wick Avenue on the lower north side. Although somewhat physically removed from the working class, Youngstown's steel and iron families invested locally and gave liberally to philanthropic causes: Joseph G. Butler established the Butler Institute of American Art (the first art museum built solely for American art), and Henry Stambaugh's estate financed the construction of Stambaugh Auditorium, among other examples.

According to John Ingham's study of American steel and iron elites, no other comparable city had such a tight clustering of wealthy industrial families in one geographic area. But by the late 1930s, consolidations had left most of the steel business in the hands of outside entities. Many of the heralded steel families left the valley entirely.[16] Youngstown Sheet and Tube remained one of the very last solidly Youngstown companies run by "Youngstown boys."

As the possibility of war loomed in 1939, Sheet and Tube and the steel industry finally began to shake off the effects of the Great Depression. Unlike

LOST YOUNGSTOWN

Bethlehem Steel and U.S. Steel, both of which had plants on the East Coast, Sheet and Tube seldom exported much steel. Yet the increasing possibility of war opened new markets for the company in South America, England and Continental Europe.[17] In 1941, Youngstown became a key city for the American war effort. Production of steel for automobiles and appliances ceased; the mills instead manufactured high-quality steel for the production of munitions and weapons.

In 1944, the Office of War Information produced a short film on the industry of Youngstown and the steelworkers themselves. In *Steel Town*, the fiery infernos of the mills and the intricate and demanding work of the steel men are carefully juxtaposed against scenes focusing on domestic and community life: steelworkers are shown playing in the Youngstown Symphony Orchestra, and their children appear as football players and students in class. Yet the finale focuses on what the world after the war might look like and what it might mean for the steel industry and the city: "When the war is over, we're going to have other problems. We know about that in Youngstown. We've had it here before. There are times when there is no smoke in the sky, and mills were quiet. The streets full of men, angry, questioning, wondering. We're beginning to understand that these things don't just happen in one place. They happen everywhere."[18]

The fear among economists, workers and industry was that when the enormous material needs of the war dissipated, the economy would cool down and return to the doldrums of the Great Depression. However, the building of postwar suburbs, the beginnings of a new consumer economy and, later, the construction of the interstate highway system helped buoy the economy during the 1950s and 1960s.

Youngstown Sheet and Tube looked to the burgeoning car market in 1949 and made one of the largest capital investments in the Youngstown district in decades: the company authorized nearly $5 million to expand the Campbell Works blooming mill in order to produce wider and heavier sheets for the automobile industry. (At the time, a 1949 Mercury or Ford could have a curb weight of three thousand pounds with everything from the bumper to the inside dash made from steel.) This investment, however, was designed only to keep the Youngstown mills competitive. For even though the mills seemed busier than ever, the district's production capacity seemed destined to remain at a stagnant level into the near future.

The Youngstown District represented the fourth-largest steel district in the country in the 1950s, but the center of the steel industry already appeared to have moved far away. In order to address this and other

INDUSTRIAL COLOSSUS

A faded safety sign is slowly being consumed by nature in an abandoned Youngstown Sheet and Tube mill. *Photo by the author.*

problems, the city hired the Pace and Associates firm of Chicago to review and recommend economic and urban strategies going forward. In its first study, Pace noted that mills located on large, navigable bodies of water (e.g., Cleveland, Buffalo and Chicago) were far better positioned to grow; even plants in Pittsburgh and Wheeling, West Virginia, had cheaper access to raw materials. Pace determined that it could cost as much as five dollars more per ton to make steel in a Youngstown mill compared to similar mills situated on Lake Erie. And Youngstown's mills—located on the small Mahoning River—lacked adequate amounts of water for cooling steel.[19] Pace recommended an immediate strategy aimed at diversifying the local economic base that included targeting light industry.

Apparently the basic steel industry opposed such efforts. In the 1950s, Henry Ford showed interest in building a Ford assembly plant just north of the city. According to Thomas Fuechtmann, "The major corporations, acting in coalition with local industrialists, were evidently able to obstruct the project long enough that Mr. Ford became impatient and abandoned the idea of locating in Youngstown. The proposal was effectively vetoed because it would have introduced unwanted competition in the Youngstown-area labor market."[20] It is unclear if other efforts to diversify the local economy

received a similar reception. In any event, an ongoing emphasis on the steel industry continued to dominate local politics.

The onset of the Korean War guaranteed a heavy demand for steel. As an alternative to subjecting industry and workers to wartime wage and price controls, President Truman chose to employ a National Wage Stabilization Board to keep inflationary pressures at bay. That system was endangered when the steel industry, in response to the United Steelworkers demand for wage increases, threatened to raise steel prices to a level considered unreasonable by the government. Before steelworkers could launch a nationwide strike, Truman ordered the seizure of the mills. The shockwaves of that decision ultimately reached all the way to the Supreme Court. In June 1952, the Supreme Court ruled in the case of *Youngstown Sheet & Tube Co. v. Sawyer* that Truman's actions overstepped the boundaries of executive power. Still, the court's decision failed to prevent a strike. Instead, the threat of an industry-wide strike became a palpable fear every time contracts came up for renegotiation.

With the war in the rearview mirror, the specter of another proposed merger with Bethlehem Steel emerged again in 1954. In an article from August 15, 1954, the *Youngstown Vindicator* addressed the forces that had been building to promote another merger effort: "Ever since 1929 and 1930, when the merger of the two firms was blocked by a group headed by Cyrus S. Eaton—at a cost of some fine friendships and some big fortunes—there have been growing signs that the two firms, second largest and sixth largest in the industry, were considered by many as 'made for each other' and certain to eventually become one." Bethlehem Steel still felt it needed Sheet and Tube's Indiana Harbor and South Chicago Works in order to remain competitive, and many in Youngstown still felt that any merger would make the city a second-rate mill town subject entirely to outside control.

The business environment of the 1950s helped facilitate a large number of mergers and acquisitions, so much so that the Eisenhower administration feared the trend could ultimately distort the economy.[21] In particular, the already concentrated production power of the steel industry worried the administration. U.S. Steel represented 30 percent of the steel market; if the merger proceeded as planned, Bethlehem would have captured 20 percent. The Department of Justice came out against the deal, and in November 1958, a U.S. District Court struck down the merger as a violation of the Clayton Antitrust Act.

Sheet and Tube enjoyed its best year yet in 1955: sales, production and products shipped all reached new highs. Still, much of this increased

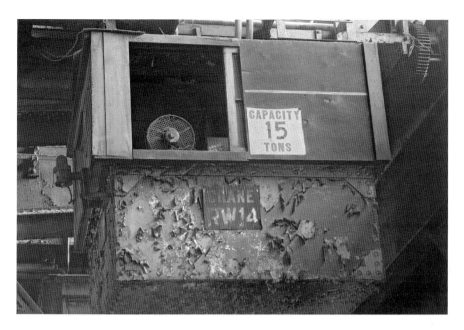

Paint gradually peels away from a rotting crane inside the former Campbell Works. *Photo by the author.*

productivity came from the Chicago district operations, which had received nearly $250 million in investment since 1950. Youngstown operations benefited from a two-year construction process to upgrade the hot-strip facilities in Campbell—one of the most significant investments in years. But by 1957, Indiana Harbor had received a new seamless pipe mill, an investment designed to improve the company's decreasing share of the pipe market. The *Youngstown Vindicator* congratulated the Chicago district and the company but added that it hoped there would be "plenty of orders left over for its Campbell Works units."[22]

Faced with increasingly difficult problems related to Youngstown's landlocked location, the city and Sheet and Tube once again turned to an old silver bullet: the Lake Erie–Ohio River Waterway. The idea of the lake-to-river canal dated back to the nineteenth century, but it was not until after the explosion of industrialization in the twentieth century that the canal found a real champion.

For years, the center of manufacturing continued to move westward, threatening the traditional industrial heartland in Ohio and neighboring states. Michael Kirwan, a congressional representative from Youngstown, brought forward the idea of creating a new "golden circle" of water-based

transportation to Washington in the early 1960s.[23] The plan called for building a massive canal system linking the Great Lakes with the Ohio and eventually Mississippi Rivers. According to its proponents, the canal would help industrial communities overcome expensive transportation costs and shorten the routes needed to bring in raw materials and send out goods to market. It also looked to be the most expensive and ambitious public works project in American history. A.S. Glossbrenner, president of Youngstown Sheet and Tube, soon joined Kirwan as a champion of the project in the early 1960s.

Glossbrenner and the political establishment of Youngstown came to see the canal as perhaps the city's last chance to hold on to its position in the manufacturing world. While Kirwan worked in the nation's capital, city council and local officials put together informational seminars and engaged in a flurry of press-related activities. At the Idora Ballroom in January 1962, members of the U.S. Army Corps of Engineers outlined the proposed canal routes through Ohio: the canal would start at Ashtabula and make its way to the Ohio River by way of the Mahoning and Beaver Rivers. Glossbrenner himself made an impassioned speech in support of the project, warning that "cities can be destroyed as effectively by adverse economic conditions

The hulking carcass of an old mill represents one of the last of the Youngstown Sheet and Tube complexes. *Photo by the author.*

INDUSTRIAL COLOSSUS

as they can by shellfire."[24] The engineers ultimately recommended that the $500,000 restudy commence. A potent opposition, however, soon formed against it.

David McDonald, president of the United Steelworkers, threw his support behind the project in the early spring. The steelworkers' union tried to drum up regional support by claiming that the canal could only strengthen the position of the landlocked mills of Youngstown, Wheeling and Pittsburgh. Nevertheless, the mayor of Pittsburgh, most of Alleghany County's politicians and the railroad companies spoke out vehemently against the plan at a hearing in Pittsburgh.[25] In general, the railroad barons saw the waterway as a possible threat to their business, and they derided the idea of a canal as anachronistic. Glossbrenner attempted to win over the coal industry by arguing that reduced shipping costs would only benefit them, and in any case, the health of Sheet and Tube and other steel companies meant more profits for the coal industry. Kirwan had the more difficult task: winning over business interests in Pittsburgh and Cleveland who viewed the canal as a benefit only to Youngstown.

The U.S. Army of Corps of Engineers completed the five-year study in 1966 and gave its approval for construction. By the fall, Kirwan had succeeded in getting a $500,000 appropriation for the canal's planning attached to a public works bill. The total cost of the 120-mile canal was estimated at upward of $948 million.[26] If Congress allotted funds, engineers calculated that it would take a decade to construct. Yet even Michael Kirwan's stature in Washington could not win over the growing list of interests opposed to the canal in 1966. "I hate to see public money thrown away to connect waterways already connected by good rail and highway transport," said Representative Robert Corbett of Pennsylvania. Kirwan quipped at critics: "Foolish people say the canal is for Youngstown when it is for the country…and the world!"[27]

But from the Upper Ohio Valley to Pittsburgh, opposition only hardened. The effort to win approval for the canal finally died in 1967. Amazingly enough, Congressman James Traficant attempted to revive the idea nearly two decades later—long after the closing of the local mills. Traficant billed the idea of the canal as a way to economically revive the Great Lakes region itself. Yet like Michael Kirwan's attempts to create "Kirwan's Ditch," as his detractors labeled it, Traficant's efforts to resuscitate the canal foundered.

Youngstown remained a steel town throughout the 1960s, regardless of the events surrounding the canal. The city added a "Steelmark" logo (the first municipality to do so) in the sidewalk near the Wick Avenue Bridge

in 1963. When talk of creating a Federal Plaza in downtown began to percolate, the Mahoning Valley Industrial Council recommended changing Central Square into the "Steel Plaza."[28]

The first real challenge to Youngstown's identity as a steel city came in 1969. After many rumors, word spread that the Lykes Corporation had acquired Youngstown Sheet and Tube. In one fell swoop, the last independent steel mill in the city passed into the hands of a company primarily noted for its involvement in the shipping business. Lykes accomplished in a very short time period what Bethlehem Steel proved unable to do in twenty-five years of trying. Sheet and Tube's stock was delisted from the market and a sense of dread pervaded the city. Many wondered what would become of "the boss."

Despite the fact that the company declared record earnings as recently as 1964, myriad problems loomed just beneath the surface. Unlike the Japanese and European steel mills rebuilt after World War II with the latest in technology, many of Sheet and Tube's open-hearth facilities dated back to the beginning of the century. Brier Hill's famed "Jenny" blast furnace, although rebuilt and enlarged after the Great War, dated back to the nineteenth century. As the company moved forward into the 1970s under the Lykes Corporation, even basic maintenance of existing equipment became problematic. "It was just that there was no preventive maintenance," said Robert Horvatt, who worked in Campbell. "It [the mill] was all patched together just to keep it running."[29] Walter Meub also worked during the Lykes era and remembered the enormous challenges: "To operate until equipment failures shut you down was just not good steel mill practice…It didn't make sense."[30]

Only the continuation of the Vietnam War and the robust market for steel kept Lykes's Youngstown operations going. But the industry's luck changed in 1974. The oil embargo and rising energy prices dramatically impacted the automotive market and, hence, the market for steel. According to metals expert Christopher Hall, "In each area—capital expenditure plans, pollution control agreements, and the labor contract—the companies' decisions were based on the assumption of sustained long-term growth in the steel market."[31] Instead, it soon became clear that a combination of overcapacity, outdated facilities, replacements for steel (plastic, aluminum, etc.) and foreign imports were dramatically changing the market. Youngstown Sheet and Tube became the first victim of the ensuing shake out.

Despite talk of constructing a basic oxygen furnace and making other promised investments, 700 workers received notice that they would be laid off immediately in the late summer of 1976. The company eliminated 150

INDUSTRIAL COLOSSUS

The sun sets on an old employee locker room in an abandoned bar mill. *Photo by the author.*

white-collar workers from its corporate headquarters in Boardman in August 1977. But this was a just a prelude. The real disaster came on September 19, 1977. Company officials that day announced the imminent liquidation of 5,000 workers at the Campbell Works, which was slated for closure, and the immediate transfer of corporate headquarters to Chicago. Only the Brier Hill Works would remain in operation, according to Jennings R. Lambeth, president of the company. The enormity of the decision shook the city to its core. Sheet and Tube's decision represented the largest peacetime plant shutdown in American history up to that point.

Youngstowners immediately responded. Four different organizations emerged within the year to propose alternatives for the community going forward: the Ecumenical Coalition (made up of a diverse group of local church leaders, steelworkers and community activists) proposed to purchase the Campbell Works and run it under a model of community-worker joint ownership; Reverend William Hogan led a group seeking to create a joint steelmaking venture; the Mahoning Valley Economic Development Committee and Mayor J. Philip Richley wanted to create a steel research center in part of the Campbell Works; and Dr. Karl Fetters advanced the idea of investing in building modern electric arc furnaces at the abandoned Campbell facility. A delegation from the city even traveled

LOST YOUNGSTOWN

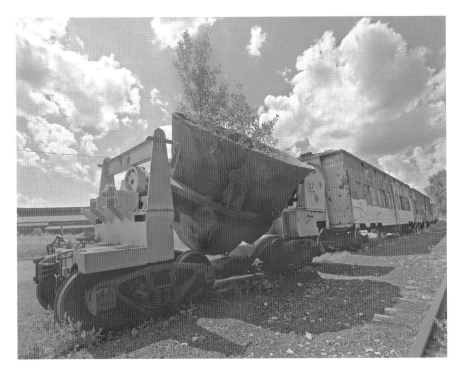

A tree grows inside a long-forgotten hot metal ladle car. *Photo by the author.*

to Japan to explore the possibility of a Japanese company taking over the Campbell Works. Each organization vied for the attention of government agencies, several of which were looking at Youngstown as an example of what urban and industrial policy might be going forward.

The Ecumenical Coalition's campaign attracted national attention, garnering detailed specials on NBC and drawing in the likes of famed historian-lawyer Staughton Lynd and political economist Gar Alperovitz to its cause. The coalition oversaw the "Save Our Valley" campaign, which set up accounts in order collect donations to help facilitate the effort to purchase the Campbell Works. The coalition hoped that by collecting at least $12 million, it could help convince the government of the seriousness of the community's effort and hence facilitate the estimated $500 million in government-guaranteed loans needed to recapitalize the mill.[32]

Mayor Richley and the Mahoning Valley Economic Development Committee's National Steel Center took a different tack. Borrowing its initial idea from Attorney Richard McLaughlin's 1973 concept, the group hoped to attract the attention of President Carter, who was thought to

INDUSTRIAL COLOSSUS

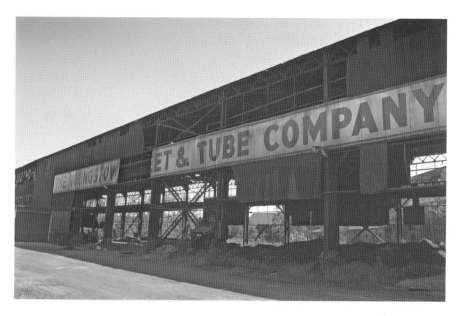

A dilapidated Youngstown Sheet and Tube sign is one of the last left in the area. *Photo by the author.*

be considering funding one of the possible alternatives put forward to help ameliorate the economic impact of the closure of the Campbell Works. The first part of the proposal involved turning Sheet and Tube's abandoned research center in Boardman into a research facility for the entire steel industry. The second element concerned transforming the Campbell Works (and perhaps the Brier Hill Works, which was rumored to be closing) into a "demonstration center" for new technologies. The committee dubbed the proposed center the "New Steel Company" of Youngstown. Like the Ecumenical Coalition's proposal, it had final costs that could have approached nearly half a billion dollars.

The Carter administration ultimately declined to fund any of the ventures. On December 5, 1978, Lykes merged with the LTV Corporation, the parent company of Jones and Laughlin Steel. One year later, the Brier Hill Works shut down. By the summer of 1981, Youngstown Sheet and Tube had ceased to exist as a legal entity.

The silent mills continued to linger on the landscape for years to come, boneyards and industrial parks forming in their midst. Today, very little of the once awesome infrastructure of Youngstown Sheet and Tube exists. Yet no markers or monuments remind us of its passing. A group of preservationists fought to save the Jeanette "Jenny" Furnace (immortalized in song by Bruce

Springsteen) from the wrecking ball in the 1990s but to no avail. Part of the former Brier Hill Works is now home to the Vallourec Star steel mill; its pipe products represent the continuance of the Youngstown steel tradition today. And the legacy of Sheet and Tube lives on in the steel of bridges, schools and skyscrapers around the country. The sons and daughters of steel helped build America, and they made the label "Quality Youngstown Service" known throughout the world. Neither their struggle nor the name Youngstown Sheet and Tube will soon be forgotten.

2
REPUBLIC RUBBER

A solitary smokestack, defying both time and the elements, reaches out like a spire aimed straight toward the heavens on Albert Street. Surrounded by weathered buildings and encroaching nature, this stack still announces the presence of the remains of Republic Rubber, one of the most important companies in Youngstown's history. Founded by ambitious local industrialists looking to challenge the rubber barons of Akron, Republic became a storied enterprise. The Albert Street plant survived commodity collapses, the Depression and World War II. During the 1970s, it became one of the most closely watched experiments in worker ownership in the country. While the story of steel dominates much of Youngstown's history, Republic symbolizes the other manufacturing concerns that made the city an industrial colossus.

The consolidation of the iron and steel industry at the end of the nineteenth century left a small number of local industrialists with a large outlay of money for capital investment. A portion of those monies ended up going to create the Youngstown Iron Sheet and Tube Company; another portion went to create more diverse companies like General Fireproofing (which would eventually become the industry leader in office furniture), the Ohio Leather Company in Girard and the Mahoning Rubber Manufacturing Company.

The Mahoning Rubber Manufacturing Company came into existence on February 28, 1901. The decision was made to locate the new plant on a combination of donated farmland and land once occupied by the American Belting Company near Crab Creek on the city's east side. Capitalized at

LOST YOUNGSTOWN

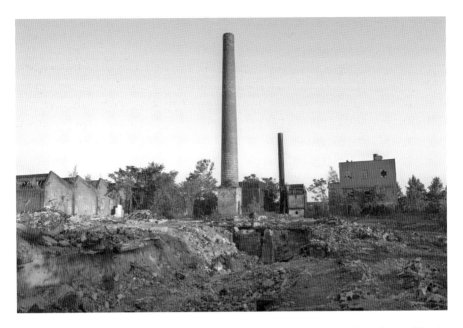

A solitary smokestack remains inside the ruins of Republic Rubber on Albert Street. *Photo by the author.*

nearly a half million dollars, the company had directors and officers who included some of the most prominent men in the community, such as George Tod, John C. Wick and H.K. Wick, who served as the company's first president.[33] The name was changed to the Republic Rubber Company at the end of 1901, and the plant itself came online in 1902. Initially, Republic had eleven acres of factory workspace—a rather modest layout. The early product lines consisted mostly of rubber hose—for both commercial and consumer use—belting, molded tools, sheet packing, rubber covered rolls and railroad goods, especially compressed air brakes.[34]

Republic Rubber began operating in a time when, like steel, rubber was becoming an indispensable part of the modern industrial society. "Rubber," however, is a very general term, one that encompasses a wide variety of products made using a wide variety of methods. The first great explosion in the use of rubber began in the last decade of the nineteenth century, when worldwide demand increased many times over.[35] The invention of the pneumatic tire allowed for smooth bicycle rides at higher speeds, beginning the golden age of bicycles in the 1890s. A huge market for production developed in Ohio.[36] The market for golf balls (with rubber cores) also exploded around the same time; Republic quickly added them to its line

of products. But the real increase in the demand for rubber came with the automobile market.

In 1905, the company constructed the first tire plant on the facilities; two years later, additions were made in order to produce solid truck tires. The Canadian Rubber Company in Montreal quickly bought the rights to distribute Republic side wire tires in Canada. The industry rapidly moved toward manufacturing pneumatic tires for cars. (Republic made the inner tubes for pneumatics on site.)

The company's break through came with development of one of the first nonskid tires, the Staggard Tread tire, which the company patented in 1908.[37] Consisting of six rows of studs, the Staggard Tread became one of the top-selling tires, along with lines made by Federal, Firestone, the United States Rubber Company, Kelly-Springfield and Goodyear. Republic created a character known as "Old Man Mileage" (who bore more than a passing resemblance to Uncle Sam) to grace their ads. Old Man Mileage appeared in ads with a dog-named Stag (for Staggard Tread), and he proclaimed, "Tire economy comes only from tire quality."[38]

Republic Rubber distributors spread as far as California. In 1912, the company built a distribution branch at the corner of Golden Gate Avenue and Hyde Street in San Francisco's "auto row." After partnering with the National Auto Supply Company, Republic opened a factory branch in Oklahoma. More distributorships spread to Seattle, Portland and Los Angeles. Republic became "one of the most important factories of its kind in the world."[39]

Employee-management relations came to the fore locally after the East Youngstown riot of 1916, when ill-housed, overworked strikers burned down most of the village after a firefight with men hired by Youngstown Sheet and Tube. Sheet and Tube and other companies struggled in the aftermath to provide new outlets for workers, usually at company-sponsored events at parks and dance halls or at picnics at places like Idora Park. Republic, however, became the first company locally to build a facility for workers.

Opened in 1914, Republic's employee club (located across from the plant) was a large brick-and-concrete structure. Although a dining facility for management occupied part of the building, the facilities and the grounds (which covered twenty-seven acres) were dedicated for the use of the rank and file. Employees paid one dollar per year for membership, and within a few weeks of its opening, 627 of the company's 2,300 workers had joined.[40] The basement contained several bowling lanes, a cigar room, a gym and showers on one side; general recreational facilities, pool tables and reading rooms occupied the other. The upper two floors were mostly dedicated to

LOST YOUNGSTOWN

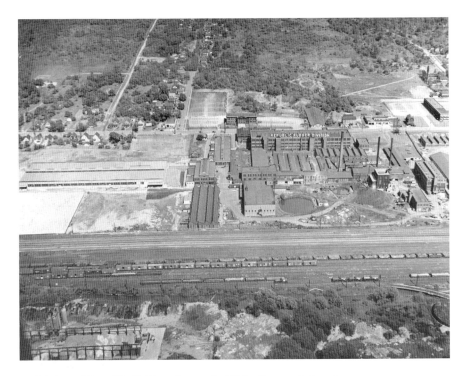

Aerial view of Republic Rubber, circa early 1950s. *Courtesy of the author.*

dining. The cafeteria took up most of the first floor, but the second floor was given over to the official dining room, a fancier operation opened to all dues payers. Living quarters for the club's manager and for members of Republic's volunteer fire department rounded out the upper floor. The club later built tennis courts and a baseball field on the grounds.

While the facilities did provide much-needed recreational opportunities in a growing industrial city with a dearth of such affordable options, it also was obviously intended to ease tensions between rank-and-file workers and the company itself. Rubber company officials from as far as Spokane, Washington, came to tour the facility.[41] General Fireproofing later followed Republic's lead, albeit in a more modest way—building a recreational complex on the city's north side. Youngstown Sheet and Tube used its property at Coalburg Lake in Trumbull County to host picnics and company outings.

The riot in East Youngstown also led several companies, including Republic Rubber, into the housing business. Affordable and safe housing had not kept up with the city's explosive population growth, and the spread of squalid slum conditions posed the prospect of further urban unrest.

INDUSTRIAL COLOSSUS

Youngstown Sheet and Tube moved first, forming the Buckeye Land Company and pioneering the first prefabricated concrete apartment units in East Youngstown. The creation of the National Housing Association (NHA) in 1910 brought together experts and urban leaders around the country to deal with the national housing problem.

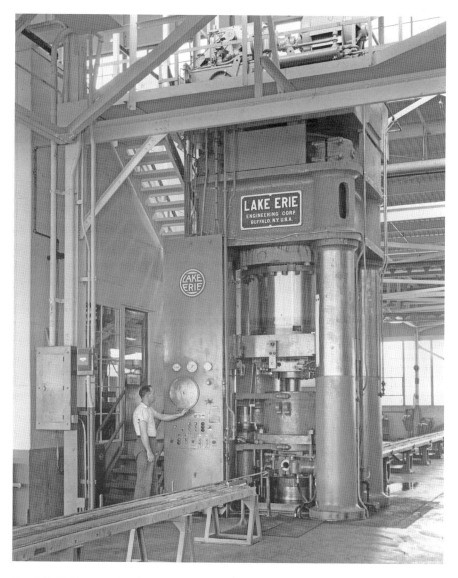

Republic Rubber employed over two thousand workers at one point, making it one of the area's largest employers outside the steel industry. *Courtesy of the author.*

LOST YOUNGSTOWN

The NHA praised Youngstown businesses for seeking its advice in constructing company housing.[42] Housing experts conferred with the Carnegie Steel Company, which built two hundred houses for its workers in nearby McDonald, Ohio. General Fireproofing built a variety of units near its plant on Logan Avenue; the Brier Hill Steel Company followed suit near its plant on the north side, as did the Ohio Leather Company in Girard. Republic Rubber soon followed. In a partnership with Dollar Savings and Trust Company, Republic built fifty houses—all semi-fireproof dwellings made of brick and stucco—on twelve acres of land near the Albert Street plant. The Realty Trust Company organized the building of the units themselves, which cost around $200,000.

Republic employed over two thousand workers by the beginning of the 1920s, and the plant itself had expanded to occupy forty-five acres next to Truscon Steel. The company also introduced the first of several campaigns aimed at getting residents to buy locally made Republic tires—as nearly three thousand a day were then being produced. Dubbed "Republic Rubber Week," the initiative emphasized Republic's popularity in major cities with a call to buy locally so as to employ local workers. First announced by the company in 1921, Mayor George Oles, along with the chamber of commerce, proclaimed it an annual event in 1922. During the first week in June, visitors toured the plant, witnessing the making of Republic's "Air Ped" rubber soles for golfers.[43] President Harding himself praised Republic Rubber Week and the industriousness of Youngstown in a letter to the mayor in 1922.[44] Yet the company's fortunes, and those of many other rubber companies, were about to change.

The massive recession of the early 1920s led to a serious downturn in the industry. Goodyear—the giant of the industry, along with Firestone—nearly went bankrupt in 1920.[45] In 1923, Republic Rubber went into receivership as the company's business declined dramatically. The plant and the company's assets went up for auction in the spring of that year. Rumors abounded that Henry Ford planned to bid; his company pursued a strategy of vertical integration that emphasized acquiring plants that produced parts for Ford automobiles.[46] But the Lee Tire and Rubber Company ended up acquiring Republic. Founded in Conshohocken, Pennsylvania, by J. Ellwood Lee, who began his career in medical supplies, "Lee of Conshohocken" became a widely known name in the industry. Upon acquiring Republic, Lee announced that all production of pneumatic tires would shift to the Conshohocken plant, and production of solid rubber tires and mechanical rubber parts would be the new focus of the Albert Street facility. The Youngstown plant became the Republic

INDUSTRIAL COLOSSUS

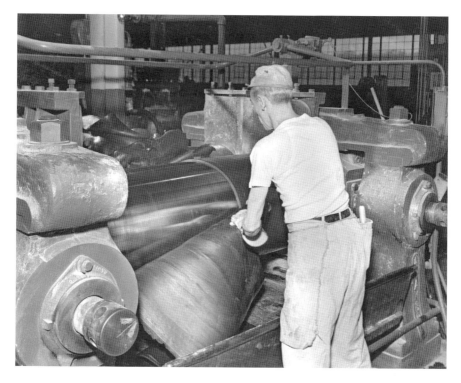

At one point, Republic Rubber produced everything from rubber golf ball cores to early car tires. *Courtesy of the author.*

Rubber division of Lee Tire and Rubber. Republic avoided disaster, and about 1,800 workers retained their jobs.[47]

While the '20s roared, Republic spent most of the middle and latter part of the decade rebuilding. Republic began producing three thousand rubber rugs a month (perfect for cleaning in the sooty environment of Youngstown) for domestic use and a nonskid model for use in airplanes. Record sales were recorded for the month of March, and Republic's sales manager O.S. Dollison was anxious to reestablish the importance of rubber for the local economy: "Many Youngstown people have the idea that you can't make rubber in Youngstown. Those people ought to see this plant, the finest little rubber plant in the country."[48]

The coming of the Depression caused the chamber of commerce to revive the "buy local" campaigns that had been so much a part of Republic Rubber Week in the early 1920s. As part of a multipronged effort entitled "Youngstown Folks Buy Youngstown-Made Products," the chamber promoted the products of various local businesses. Republic's garden hoses

were aggressively marketed, as were force cups for sinks, indoor and outdoor mats and runners. Republic provided thousands of products for the local mills; however, production had declined dramatically during the early years of the Depression. Instead, Republic's products found their way into a variety of New Deal projects, including the Tennessee Valley Authority, and in breweries, which enjoyed expanding markets after the end of Prohibition. As the business climate improved at the end of the decade, Republic began making rubber conveyor belts capable of handling superheated pieces of coke for the local steel mills. But much like the situation with Youngstown steel, it would be war that truly revived the local economy and Republic Rubber's fortunes.

Prior to World War II, natural rubber dominated the market. The British, owing to their vast colonial resources, controlled the majority of that market. Rubber came from naturally occurring latex rubber in plants like *Hevea brasiliensis*, which is mostly found in tropical environments; Republic's purchasing agents bought its supply of crude rubber from the Malayan peninsula, then in the hands of the British. Attempts to make synthetic rubber dated back to the nineteenth century, largely to little avail. The first big success with synthetics originated in Nazi Germany in the 1930s. The Nazi's synthetic product came to be controlled by a cartel consisting of the German company I.G. Farben and the Standard Oil Company.

As the Japanese overran British rubber-producing colonies in 1942, President Roosevelt created the Office of Rubber Director, which, among other things, oversaw American efforts to create viable synthetic rubber supplies. The number of rubber products produced was restricted due to military applications during the war, and tire rationing took effect until the end of 1945. Scrap rubber drives appeared all over the country, and civilians turned in old garden hoses, gloves and shoes for the war effort. Republic's line of finished goods shrank to essentially just products for the war: "Mae West" life vests for pilots downed in the pacific, hosing for fighters and bombers, gaskets and ammunition cartridge holders, among other items.

The end of the war ushered in peacetime prosperity for Youngstown. Local industry quickly retooled, and Republic's line of goods expanded to encompass twenty thousand products for domestic and commercial use. Several large additions were added to the Albert Street plant, which had grown to encompass twenty-three industrial buildings with well over 600,000 square feet of space, but employment—largely due to labor-saving technologies—hovered at just over 1,400. The workforce largely consisted of men and women with between seventeen and twenty-five years of

INDUSTRIAL COLOSSUS

Various types of industrial hose eventually became the centerpiece of Republic Rubber's business model. *Courtesy of the author.*

service.[49] Republic's products also became more complicated to make and more carefully designed to meet very exact customer specifications, as the company's representatives carefully pointed out:

> *All raw materials are tested upon receipt and includes* [sic] *belting and hose ducks, hose cords, various other fabrics; natural, reclaimed rubber, plasticizers, accelerators, wire and hundreds of other ingredients. Each batch of compound has all of its ingredients carefully weighed to pre-determined specifications; is milled by mechanical and hand-mixing mills also according to specified times; the temperature of the mill roll is controlled to suit the particular batch being milled. Test pieces are then cut from each lot and tested in the laboratory for hardness, elongation, color, etc.*[50]

Republic prospered during the 1950s, becoming one of the leading producers of fire hoses in the world for both city fire departments and naval aircraft—including the largest navy ship ever built.[51] And factory workers

LOST YOUNGSTOWN

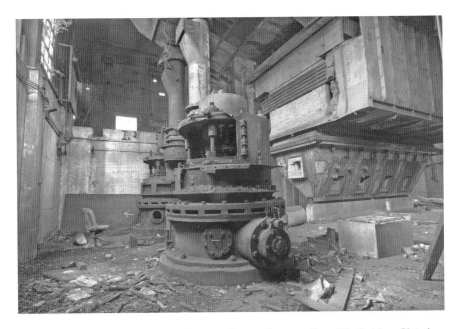

For years, a labyrinth of ruins has drawn urban explorers to Republic Rubber. *Photo by the author.*

prospered under Local 102 of the United Rubber Workers. But as the 1960s dawned, Lee began to revaluate its relationship with Republic Rubber. In the spring of 1963, rumors began swirling that the company intended to sell the Albert Street plant. In August, nearly seven hundred office and factory personnel found themselves laid off or subject to dramatically reduced work schedules. Days later, Republic employees struck the Albert Street plant; workers at Conshohocken had been on strike since July. Locals began to fear that Lee could sell the plant to a competitor, who might then shut it down all together. The Aeroquip Corporation, a leading producer of hoses and fittings for the military, reportedly eyed purchasing Republic, but the ongoing strike complicated any potential sale. When the strike finally ended in late October, the possibility of a sale to Aeroquip became more likelihood than a rumor.

Aeroquip bought Republic Rubber in December 1963. Unlike what would happen in 1969 with the Lykes takeover of Youngstown Sheet and Tube, the deal seemed to provide the best opportunity for Republic's survival. Formed in 1940, the Aeroquip Corporation was the brainchild of Peter Hurst. A skilled engineer, Hurst had helped pioneer a type of hydraulic hose that did not require the costly and time-consuming use of non-reusable fittings. Hurst came

INDUSTRIAL COLOSSUS

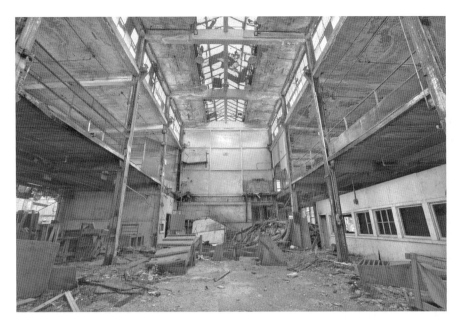

Skylights illuminate the industrial ruins of Republic Rubber. *Photo by the author.*

to Jackson, Michigan, just before the war in Europe broke out. He so impressed members of Jackson's business community that he quickly found himself with $10,000 in start-up investment, which he used to form Aeroquip. Nearly a year after being purchased by Aeroquip, Republic found itself becoming the most profitable of the company's subsidiaries, and Republic became the sole producer of hosing and rubber belting for the company.

Expanded engineering and storage facilities were added in 1966, just as the company enjoyed the best fiscal years in its history. Yet it was revealed in 1968 that Westinghouse Electric had nearly acquired Aeroquip. While the Westinghouse deal never came to fruition, Aeroquip itself began to pursue aggressive acquisitions under the guidance of its president, Don McKone. The company, like many others at the time, sought to diversify its holdings and to acquire independent parts and suppliers. For the next three years, Republic continued to supply Aeroquip with rubber hose and braided wire hose, but in a seemingly stunning turn of events, Aeroquip began to target Republic for cutbacks in 1971.

The Lykes takeover of Sheet and Tube was widely maligned in Youngstown by 1971, and it seemed that perhaps the Aeroquip takeover of Republic Rubber might turn out to be equally as problematic, especially after the Aeroquip Corporation itself was acquired by Libbey-Owens-Ford

LOST YOUNGSTOWN

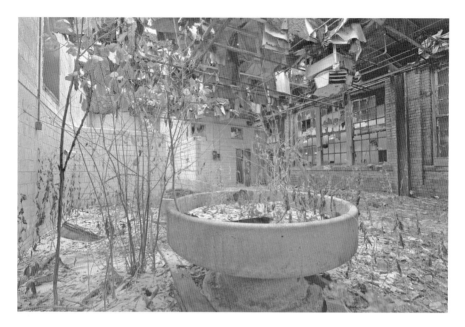

Weeds reclaim an old washroom. *Photo by the author.*

in 1968. Libbey-Owens-Ford primarily produced glass for the automotive industry, but like so many companies in the 1960s, it sought to diversify its product line. By 1972, only three years after acquiring Aeroquip, 275 jobs had been eliminated and 150 more layoffs were announced in the summer of 1972. This all emanated from the company's decision to cease production of molded rubber goods, which once constituted a key line for Republic. Much like Youngstown Sheet and Tube, Republic suffered from underinvestment, and Aeroquip/Libbey-Owens-Ford claimed that Republic's inadequate facilities and aged equipment—along with increasing competition in the marketplace—forced the cutbacks.

Around one thousand workers labored at the Albert Street plant in 1969, but only around three hundred remained in 1977. In April 1978, only months after the announcement of the shutdown at the Campbell Works, word came down that Republic Rubber would close. Local 102 union representatives and Republic workers traveled to a Libbey-Owen's Ford's shareholder meeting in Toledo but could gain no audience. Company officials claimed that energy costs, competition and high-maintenance facilities contributed to the move; they emphasized that no actions by either the company or the union could reverse the decision. Republic workers denounced the closure. According to Frank Ciarniello, president of United Rubber Workers Local 102, "While

INDUSTRIAL COLOSSUS

we were working with antiquated equipment up here, they were sending new equipment into the South."[52] And indeed, the company announced plans to build a new plant in the Southwest. The Ohio Public Interest campaign (an organization that helped get a bill passed calling for advanced notices in cases of plant shutdowns) and Local 102 launched a campaign aimed to save the plant, but little came of the effort.

Months after Republic Rubber closed its doors, a group of former Aeroquip employees announced that they would be reopening part of the plant. The new company, Republic Hose, planned to initially draw back 175 employees in order to begin operations in one section of the old plant. While the city itself remained embroiled in the fallout over the Campbell Works, Mayor J. Philip Richley pledged his support. Republic Hose planned to produce hydraulic hose, and after some negotiations, Aeroquip agreed to both sell the Albert Street plant to the new company and purchase hose from it. An application for a loan guarantee went to the Economic Development Administration, and a loan was arranged through Dollar Savings and Trust. In exchange for an Urban Economic Development Action grant, Republic agreed to turn over thirty-three acres of the old plant to the city, which planned on demolishing many of the outmoded structures.

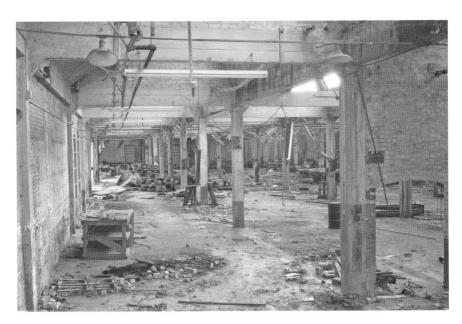

An old workroom remains on the edges of the former Republic Rubber Company. *Photo by the author.*

LOST YOUNGSTOWN

A November 12, 1978 editorial in the *Youngstown Vindicator* described the effort to reopen Republic as "a virtual blueprint for community commitment." Nor was Republic alone. A community effort in Indianapolis to keep a Uniroyal rubber plant open was drawing national attention, and it closely tracked the effort to reopen Republic in Youngstown. The Indianapolis story, involving several local banks, rank-and-file workers and the former owners—who agreed to sell the company—led to the creation of a new employee-owned firm, the Indianapolis Rubber Company.

The media converged on Indianapolis, and soon they came to Youngstown—not only to cover the effort to reopen the former Campbell Works but also to tell the story of the rebirth of Republic. In April 1979, the city held a ribbon cutting to welcome Republic Hose to Albert Street. In a dramatic speech, Senator John Glenn derided "one of the great lies" that painted Youngstown as a dying city. "Youngstown wasn't dead then, and it isn't dead now," Glenn said. "And if anyone needs proof, we have today's ceremony."[53]

On Christmas Eve 1979, *Time* came to Youngstown to chronicle the nine-month history of Republic Hose. Revenues for the first fiscal year were twice what officials expected, and the company's profits ran to about $600,000. Many employees had worked for weeks to prepare the plant, toiling in unheated buildings in the winter. Salaried positions had been cut, and wages for both management and hourly employees were greatly reduced. Vacations disappeared along with Republic's old pension plan. Yet spirits remained high in the plant, which seemed to represent—despite the failure of the plan to reopen the Sheet and Tube plants—a viable success for Youngstown. And not without reason, for Republic Hose continued to defy expectations.

Production remained 40 percent higher than it had been in the last years of Aeroquip, and workers even put in time after work to find better deals on supplies. For all its success, however, the Republic venture was not on par with the efforts to save the steel mills. As efforts ramped up to try to reopen the U.S. Steel Ohio Works, James States, director of sales of Republic, warned of the difficulty of comparing Republic's situation to that of reopening a large, integrated mill. "It's not easy. There's no set format to follow and you can't read how to do it in a book. It could work if they have commitments from people to buy their product. But it's far more difficult for a large-scale operation to get market commitments than a small one."[54] The Ohio Works never reopened, but Republic Hose continued as the last of the steel mills closed in the early 1980s.

Republic enjoyed marked success into 1984. The work remained difficult, and the employees, eighty of whom owned stock, made less than average wages

INDUSTRIAL COLOSSUS

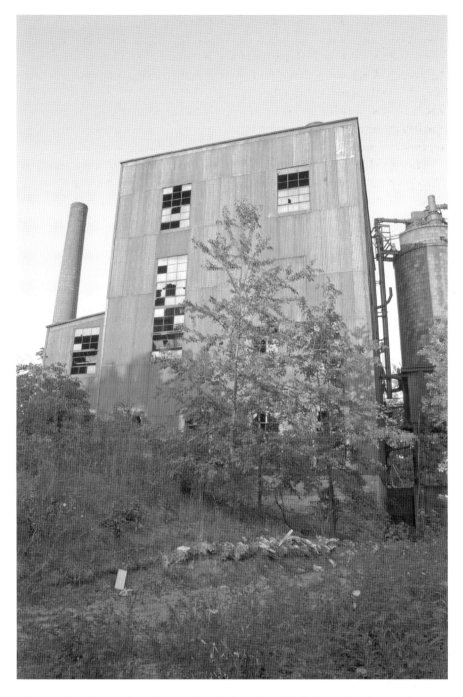

A jigsaw of broken windows glow in the twilight at Republic Rubber. *Photo by the author.*

for the manufacturing sector.⁵⁵ Product diversification and long hours kept the company going even as competitors faltered. Trouble, however, appeared as the difficult economic environment for Republic's customers—largely in agriculture, mining and construction—continued. Faltering business in 1985 left the company in serious debt; Republic needed nearly $3 million to cover outstanding debts. The company began to seek investors capable of providing a capital infusion of at least $1 million. Any such investors, could they be found, would have a commanding stake in the company.

An extended effort to broker a sale, led by Congressman James Traficant, finally bore fruit in 1986. The Goodall Rubber Company—which had been recently acquired by Trelleborg AB, a Swedish company—bought the controlling interest in Republic. It appeared the flow of red ink could now be stopped in time to save the company. In the early 1980s, Goodall's own future looked bleak. Despite losses of over $13 million, Trelleborg managed to turn the company around. The same plan that worked at Goodall—an emphasis on sales and marketing, workforce reductions and reductions in wages and salaries—was likely to be applied at Republic. Republic's workers—then down to ninety-five—still owned 49 percent of the company, at least for the moment.⁵⁶ As trade conditions improved in 1987, Republic

A fading Republic Hose sticker still clings to an old board in the long-abandoned plant. *Photo by the author.*

planned to begin shipping products to new markets in Australia and New Zealand. The company seemed to be on the upswing once again. A year later, with Republic continuing to post losses, Trelleborg took direct control of the company. But despite cost-cutting measures and a reduction in the workforce to fifty-five employees, Republic Hose's decade-long struggle ended in October 1989, when the imminent shutdown of the company was announced. The Albert Street plant shuttered for good.

 A quarter century after its demise, the ruins of Republic are concealed among a swath of vegetation, and the Albert Street corridor, once jammed during shift changes, is now mostly quiet. Yet the story of Republic Rubber remains one of the most important in Youngstown's history. For a city dominated by steel, Republic Rubber carved out an important niche in local manufacturing, and it made an international reputation for itself—one that represented Youngstown well. The story of Republic Hose, despite the ultimate closure of the company, represents one of the first chapters in the ongoing story of employee ownership in America. And as the worker-owned cooperative movement grows, the story of Republic Hose will live on.

PART II
THIRD PLACES

3
THE LIBERTY/PARAMOUNT THEATER

The northwest corner of West Federal and Hazel Street in downtown Youngstown is largely a quiet place today; only the rumble of passing cars and the voices of passersby prevail. But this empty parking lot once served as one of the most popular entertainment destinations in the city. Nearly a century ago, in the midst of wartime, Youngstown's first proper film palace opened to widespread fanfare. The Liberty Theater (which became known as the Paramount Theater in 1929) ushered in the era of the downtown movie house in Youngstown. For nearly sixty years, it entertained moviegoers, and after the theater's lights finally dimmed, the fight to save the Paramount continued. Even in a shuttered and neglected state, the theater attracted entrepreneurs, historic preservationists and the curious. When it finally met the wrecking ball in 2013, it was one of the oldest standing movie theaters in Ohio.

The corner of West Federal Street that housed the Liberty/Paramount has a storied history that reaches back into the nineteenth century. Decades before the crowds and clamor of the central business district, what is now downtown was a largely residential area. In the early part of the nineteenth century, the Caleb Wick home stood on the spot of the future Liberty Theater.

The Wick family name is one of the most recognizable in the city, and the Caleb Wick home, with its large orchards and well-manicured gardens, "set a high mark" among the residences in the city.[57] Consisting of a five-bay façade with a large porch and double-parapet chimneys, the estate dominated the landscape. The property itself stretched back to Wood Street,

LOST YOUNGSTOWN

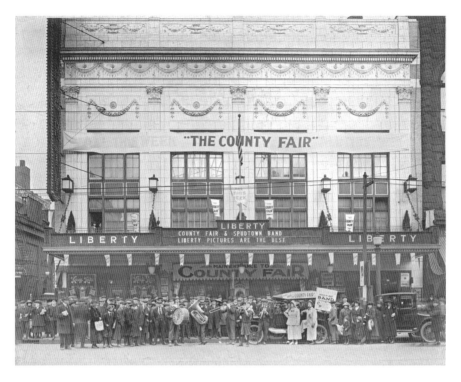

The Liberty Theater as it appeared in 1920. *Courtesy of Thomas Molocea.*

but the encroachment of businesses and the expansion of land for residential building eventually led the Wicks to move their estate to the future site of the Butler Institute of American Art.

A group of local investors erected the famed Excelsior block on the site of the old estate in 1867. A large three-story structure, the Excelsior block contained storefronts on the ground floor, office space on the second and the Excelsior Theater on the third. The Excelsior represented the first real theatrical experience in Youngstown. Built to accommodate changing scenery and heavy drop curtains, it quickly became a top entertainment destination. Yet the opening of the Grand Opera House in 1872 severely curtailed the crowds at the Excelsior. Constructed by the famed mason P. Ross Berry (who also built the original Rayen School), the Grand Opera House became the heart of Central Square—or "the Diamond," as it was then called. When the Excelsior finally declined, it was replaced by the Globe Museum, which featured "freak shows" starring performers with names like JoJo, the Dog Faced Boy.

At the end of 1916, as the possibility of America's entry into the war loomed, local officials announced that the old Excelsior block would be

torn down to make way for a theater. Ironically, the businessman behind the project, C.W. Deibel, was the son of the man who built the old Excelsior. A polymath and a regionally recognized golfer, Deibel spent his early life in New York City learning the art of tailoring. He returned to open his own shop on West Federal Street in the 1890s. After an extended illness, he moved away from tailoring and into the entertainment business. Deibel ended up running a series of nickelodeons, and in 1912, he helped open the Dome Theater at the corner of West Federal and North Hazel.

When the idea for a new luxurious movie palace for downtown came to the planning stages, Deibel's name came up immediately. He seemed like the perfect man for what proved to be the most ambitious theater project in Youngstown history to that point: the construction of the Liberty Theater. The as-of-yet-unnamed theater's investors held a write-in contest in 1916 to determine a moniker for their investment. Thousands of entries poured in. Some of the top contenders were the Premier, Guild, Paradise, Nixon, Monarch, Hazel Square, Family, Dream O Land, McKinley and Sunshine.[58] The possibility of war probably influenced the naming of the theater as the Liberty in January 1917. Four days before America entered the war, crews began demolishing the old Excelsior Theater in preparation for Youngstown's grand movie palace.

The *Youngstown Vindicator* referred to the Liberty's construction as "one of the most unusual building enterprises in Youngstown."[59] It was not overstating the case. The declaration of war against Germany required most of the steel industry to change over to wartime production. Few building projects outside of those necessary for the war effort could count on having the necessary materials. Delays mounted, and the owners feared it might take as long as two years get the available structural steel. But by the beginning of 1918, the Liberty looked like it would open on time. A crew filmed all aspects of the Liberty's construction, including the transportation of the theater's large pipe organ by truck from Alliance, Ohio. The film of the construction later showed, along with the regular features, during the Liberty's premiere week.

Unlike its other competitors, the Liberty primarily served to show "photo plays" in an atmosphere of unparalleled architectural and interior design excellence. (The theater contained no stage suitable for real vaudeville or burlesque performances.)[60] The building itself consisted of buff brick and an enframed window wall with a sumptuous white-glazed terra-cotta façade provided by the South Amboy Terra Cotta Company. The Liberty's design represented the Neoclassical style of the Adams Brothers. The exterior also contained Corinthian pilasters, medallions and swags, all of which featured

Dust and cobwebs cover the long-forgotten organ inside the Paramount Theater. *Photo by the author.*

prominently in Classical Greek and Roman architecture. The interior featured rose, green and ivory color schemes and a dome-shaped ceiling, all suited to the Adamses' style. The balcony, which also had loge seating, was cantilevered to prevent obstructed views for those sitting on the floor level. The theater could sit 1,800 guests.[61]

Several elements of the Liberty were indicative of the time. Perhaps in an effort to distinguish the theater from the nickelodeons of the day, dramatic fineries abounded in the interior. Two elegant stairways led from the lobby level to the mezzanine, which contained lounging rooms for both men and women. They came complete with desks and the Liberty's own stationery for letters. The lounging areas contained leather chairs and Persian rugs. The

mezzanine also accommodated a fireplace, divans, a lighted fountain and an aquarium. The leather chairs on the floor and in the balcony featured depictions of Lady Liberty below the armrest. House lighting colors consisted of ambers, greens and whites. A $20,000 Hillgreen-Lane organ and a full orchestra accompanied the silent films. The *Youngstown Vindicator* boasted that the Liberty represented "one of the finest theaters ever erected in this country to show photoplays."[62]

Famed Architect C. Howard Crane designed the Liberty. Known primarily for his theater buildings, Crane would revisit much of the Liberty's design with his Detroit Orchestra Hall, built in 1919. In particular, the Liberty's small lobby typified the early movie houses, according to local historian Mark Peyko. Crane's design also included two storefront retails spaces on the ground floor. "Sometimes office and retail space were part of a theater building because the real estate was so valuable," Peyko said. "In some cases, the theater and office space ended up having different ownership." A confectionary and the Liberty Cafeteria soon entered into the building's retail space. The Liberty Cafeteria actually opened in the space below the theater; it primarily offered a few select multicourse menu items.

On opening day, February 11, 1918, throngs of Youngstowners converged on the Liberty Theater. The house orchestra played the *Liberty Bell March* while patrons made their way through the doors. The lobby overflowed with flowers and cards congratulating the theater on its opening. The first episode of *The Sons of Democracy*, starring Abraham Lincoln impersonator Benjamin Chapin, played first, followed by Douglas Fairbanks in *A Modern Musketeer*. Christopher Deibel's daughters performed a brief piece honoring the Liberty, and the singing of local soprano Opal Chaney rounded out the program.[63] The opening lived up to the Liberty's motto: "A fitting shrine for the silent art." But the Liberty joined a very competitive and lively local theater scene, one that belied the city's size.

The Liberty represented a unique experience in downtown, but a wide variety of theatrical options awaited the patrons of the era. Central Square's Grand Opera House, where the Warner brothers once showed films, survived for a short period of time after the Liberty opened. Silent films screened all over town, but the era of vaudeville and burlesque still dominated.

The Hippodrome Theater, built on West Federal Street in 1915, played host to the Keith-Albee vaudeville circuit. The greatest vaudevillians of the era, including Mae West, Roy Rogers, Jack Benny and Youngstown native Rae Samuels—known as the "Blue Streak of Vaudeville"—played the Hippodrome. The Dome Theater became a top competitor of the Liberty.

LOST YOUNGSTOWN

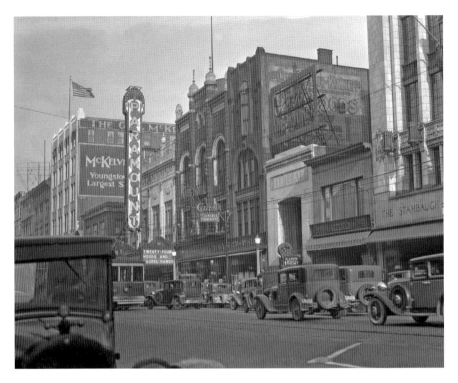

The Liberty Theater became known as the Paramount Theater in the summer of 1929. *Courtesy of Mahoning Valley Historical Society.*

Located just down the street, it featured one of the best-known orchestras in town and went on to show the first partial "talkie" in Youngstown in 1927.

The Park Theater (which would much later become the Park Burlesk) located on South Champion, primarily featured stage shows. The Regent Theater on East Federal Street opened in the 1920s and later became known for showing "race films" (featuring predominately black actors) to a largely African American audience. The Strand Theater, situated on Central Square, played second-run films, Saturday morning serials and later live rock, doo-wop and country shows. The Princess Theater, originally known as the Family Theater, survived on vaudeville and then burlesque well into the Depression—when it became known as the Grand Burlesk. And the Orpheum Theater (located on the future site of the State Theater) featured films as well. The Idora Theater at Idora Park offered vaudeville, summer stock, minstrel shows and some films. Yet the Liberty thrived in this competitive world of local entertainment; its unique movie house and top-flight pictures kept it among the best of the entertainment options in the city heading into the 1920s.

THIRD PLACES

Depictions of Lady Liberty appeared on the sides of the theater's seats. *Photo by the author.*

The Liberty quickly achieved a reputation as one of the top theaters, thanks in large part to the management skills of C.W. Deibel. Theater manager Jack Hynes later remembered Deibel's tenure at the Liberty: "He was a great gambler when it came to buying films. He would pay top price to get the picture he wanted…He had great stars like Harold Lloyd, Thomas Meighan, Gloria Swanson, the glamour of the late 1900s and early 1920s."[64] Meighan himself even made a personal appearance at the theater, thanks to Deibel. In 1923, the Liberty enjoyed the largest opening weekend yet in the city with Harold Lloyd in *Why Worry?* The

films of Fatty Arbuckle also proved to be particularly popular in the Liberty's early years.

Despite being a movie house, special events and performances did come to the Liberty. In 1922, a film of the South High School versus Rayen football game (always the biggest sporting event of the year) played to sellout crowds. The Women's Press Club held regular events at the theater, especially its annual Christmas benefit for area children. Children's matinees also occasionally featured singing and dancing routines for the kids. Livingston's clothing store held their annual fall fashion revue at the Liberty. And in a sign of things to come, the Liberty—along with the Strand and the Orpheum—began hosting annual "Paramount Weeks," screening nothing but films from Paramount Pictures. This trend foreshadowed the eventual practice of "block booking," where theaters interested in screening films with major studio stars were forced to commit to buying other films from the same studio.

The Liberty sat in one of the busiest corners of a rapidly expanding central business district during the 1920s. Youngstown's population went from 132,000 to 170,000 during the Roaring Twenties as the city arguably reached its historic peak of prosperity. "There was no such thing as the outskirts at the time, or suburbia," Youngstown resident Edward Manning later recalled. "The streetcars would bring everybody downtown. All the theaters were there, and Saturday night was just a beehive of activity."[65] More growth meant newer and bigger theaters downtown.

In 1926, the Keith-Albee Palace Theater opened in Central Square. The Palace (originally known as just the Keith-Albee) quickly became the center for vaudeville in Youngstown, but it also showed films. The Palace could seat 2,300 patrons in its elaborately decorated interior, which included an art gallery on the mezzanine. Burlesque, blackface comedies and performances from national singing acts were commonplace at the early Palace. The State Theater—featuring a long lobby, unlike the Liberty—opened on the site of the old Orpheum Theater in 1928. The State's sister theater, the Cameo Theater, opened on West Federal Street during the same period. Big changes, however, also transformed the Liberty itself.

In 1929, Paramount Pictures purchased the Liberty outright, renaming it the Paramount Theater. Paramount quickly began an elaborate remodeling. The theater remained closed for renovations from the beginning of June until the middle of July. Management installed equipment necessary to show talkies, and for the second time in a little over a decade, an elaborate opening was planned for the theater. A parade honoring the new Paramount, going

THIRD PLACES

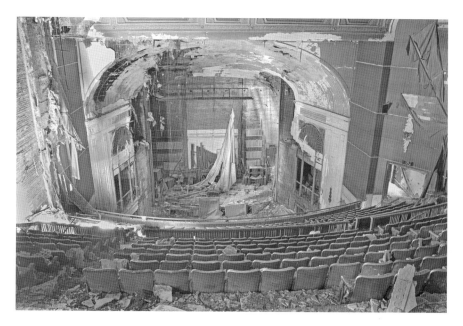

The inside the former Paramount Theater as it appeared in 2010. *Photo by the author.*

from Bentley Motors on Wick Avenue to West Federal Street, commenced in the early afternoon of July 19, 1929. As a crowd estimated at 1,500 looked on, with bands playing, Youngstown's finance director turned over the keys to the management of the newly renovated theater.[66] A sign below the marquee proudly read, "Youngstown sets the stage for Eastern, Ohio." Yet like the rest of the city, the new Paramount soon faced the uncertain future of the Great Depression.

The Depression hammered Youngstown. As unemployment skyrocketed and the steel mills ground to a near halt, a crisis set in. Poverty and privation developed to such a point that in May 1932, *Atlantic Monthly* dubbed Youngstown "the hungry city." But in the midst of the prolonged economic crisis, the last great movie house was built near the corner of West Federal and North Chestnut Streets. The Warner Theater proved to be a beautiful and lasting landmark made possible by Youngstown's famous Warner brothers. It also represented the end of the great building era for downtown movies houses.

The Warner screened only Warner Brothers' films, and in that sense, it posed no direct competition to the Paramount. The major production companies in 1931 all had movie houses in the city: Paramount-Publix operated the Paramount, State and Cameo. Fox Film Corporation ran

Decaying film dangles from the Paramount's discarded projectors. *Photo by the author.*

the Park Theater, the Palace Theater represented RKO and the Dome and the new Warner Theater represented Warner Brothers. At that point, Youngstown had as many top theaters as Cleveland and Pittsburgh.[67] However, despite the shot of confidence the new Warner bestowed on downtown, commercial business only worsened as the country made its way into the depths of the Depression.

In 1933, the Paramount entered receivership, and the State Theater closed temporarily. The Paramount-Publix Theaters Corporation, which ran two thousand plus theaters for Paramount, returned the theater to the Hazel Building Company, which, in turn, sold it to the Feiber and Shea Company. Joe Shagrin, a famed theater man, took over as manager. Shagrin had started his career as an usher at the Grand Opera House, but he made his biggest mark locally at the Park Theater. He successfully guided the Park to financial success through the first years of the Depression and seemed to be the perfect person to reverse the Paramount's fortunes. The theater formally reopened on June 4, 1933, with *The Devil Brothers*, featuring Laurel and Hardy. Shagrin had the Paramount renovated once again, installing a new "Wide Range" sound system. The system extended the frequency range, bringing out the details of sound effects and musical scores.

Other technological aspects remained rather primitive. Carbon sticks (producing a temperature of over one thousand degrees Fahrenheit) were used in projectors to supply a light source powerful enough to project through the film to the screen, which was at least 150 feet away at the Paramount. Signal dots (appearing for a brief moment on the screen) let Paramount projectionists like Louie Ipp know when to change the films reels, as movies came on different reels. The intense heat and chemical vapors produced from the carbon sticks required chimneys over the projectors. The Paramount, however, remained one of the more technologically advanced theaters in the city at the time.

The winding down of the Depression in the early 1940s brought the crowds back in full force. Blue laws (which prohibited certain activities on Sundays, such as buying alcohol or attending the theater) attracted patrons from western Pennsylvania, and special appearances by stars like the Andrews Sisters helped bring capacity crowds. Many showings were standing room only on the weekends.[68] By that time, Jack Hynes, one of the most well-known men in the local theater scene, had taken over as manager; Joe Shagrin moved on to run the Foster Theater on Glenwood full time.

Hynes knew as much about the theater business as anyone in the city. Like Shagrin, he began his career as an usher. After leaving the Strand, he

worked his way up to become the chief of service at the Dome Theater and then assistant manager at the State Theater. Hynes was not the only veteran theater man at the Paramount. During his tenure, the famed Arthur "Barney" Carnes occupied office space in the theater. Carnes designed the famous program for the opening of the Warner Theater, and rumor had it that the Warner brothers once asked him to come to work for them in California; however, Carnes reportedly refused to leave Youngstown. Most of the boxing-style posters and broadsides advertising films downtown came from his office in the Paramount.

The postwar years did not bring a return of the Depression, as many had feared. On the surface, downtown boomed, and theaters showed more films than ever. A long list of hit movies and big stars' names decorated the Paramount's marquee from 1945 to 1950: *Cynthia*, starring a young Elizabeth Taylor; *Black Gold* with Anthony Quinn; Lana Turner in *Green Dolphin Street*; *On the Town* with Gene Kelly and Frank Sinatra; the dynamic Barbara Stanwyck and Ava Gardner in *East Side, West Side*; and *Twelve O'Clock High* with Gregory Peck.

In 1951, the Paramount Theater embarked on another remodeling and grand reopening. Gerald Shea, vice-president of Shea Theaters, came to oversee the progress. The Paramount's dated heating and cooling system underwent a complete overhaul. A thick layer of new soundproof carpeting went down; new seating allowing for more legroom was installed, and the Paramount's walls received fireproof fabrics and draperies. Mohair and leather settees decorated the enlarged lounging and restroom facilities. Soundproof Austrian shades went up to diminish noise coming from the lobby into the auditorium. The grand proscenium arch was fitted with gold and blue draperies that extended down to the organ boxes. The lobby lighting changed extensively, as a new type of white plastic was added over the lights to create a diffused type of illumination. The Paramount became the third theater in the country to experiment with this new lighting scheme.[69] After the remodel, the president of Shea pronounced the Paramount the most state-of-the-art theater in Ohio.[70]

The Paramount thrived in the years after the 1951 reopening. In 1953, the theater enlarged the screen and readied the facilities for the new CinemaScope films coming out. The screen was enlarged to thirty-four by seventeen to accommodate the widescreen format, and *Arena*, the first western shown in 3-D, premiered on the new screen in the summer. The golden age of the cinema, despite the growing popularity of television, continued.

LOST YOUNGSTOWN

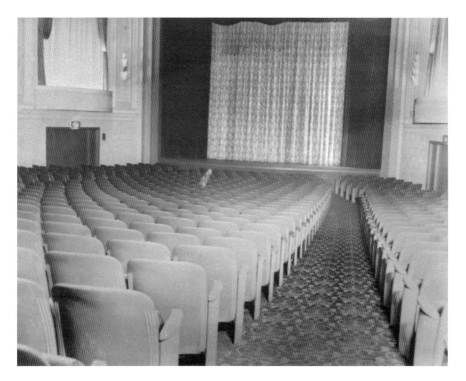

The interior of the Paramount as it appeared after a major renovation in 1951. *Courtesy of Mahoning Valley Historical Society.*

The top-three grossing films in the theater's history ran during the 1950s and 1960s: *The Robe*, which was the first film shown in CinemaScope nationally and locally; *My Fair Lady*, which ran for sixteen weeks straight in 1965; and the rerelease of *Gone with the Wind*, the most popular film to ever play at the Paramount, returned in a new 70mm format from December 1967 to May 1968. Every five years or so, the film screened at the Paramount—such was its popularity. Only the Paramount and the State Theater featured 70mm films until the opening of the Wedgewood Theater in Austintown.

"That's when theaters were theaters," explained Bob Jacobs, who frequented the Paramount as a child. "I can remember sitting down in the Paramount when the movie would come on. The programming would start, and then they would have a huge curtain that was transparent…and then the curtain would slowly open to reveal the screen. And then you would settle in to watch the movie, but not before you saw the newsreel, and you always saw a cartoon."[71]

THIRD PLACES

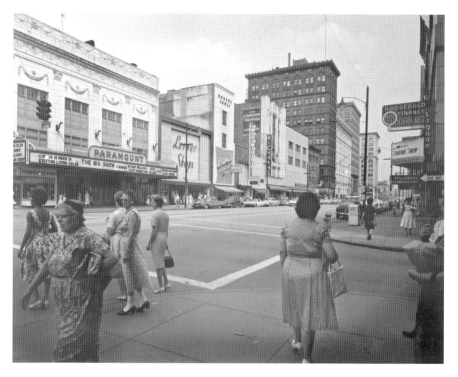

Busy downtown shoppers cross the street in front of the Paramount Theater in 1961. *Courtesy of Mark Peyko.*

Crowds waiting for the show regularly spilled out of lobby into the street. "People lined up outside going down Hazel Street," recalled former Paramount employee Rita Russell. "And that was a regular occurrence if you got a big show, especially on the weekends."[72] Downtown appeared to be as economically healthy as ever, and so did the Paramount. But as early as the 1950s, the movement of residents and retail away from the city core into the suburbs began to reshape downtown and undermine the long-term viability of its theaters.

After reaching a historical high of 170,000, Youngstown's population declined to 166,000 in 1960. The population of Mahoning County, however, continued to rise. Most of that growth took place in the blossoming suburbs of Boardman, Austintown, Canfield and Poland. Businesses, cultural institutions and retail soon followed. The opening of the Greater Boardman Plaza in 1951 provided the first shopping experience far outside the traditional downtown retail district. The Newport Theater, located just over the line from the south side of the city in Boardman, was the first theater

LOST YOUNGSTOWN

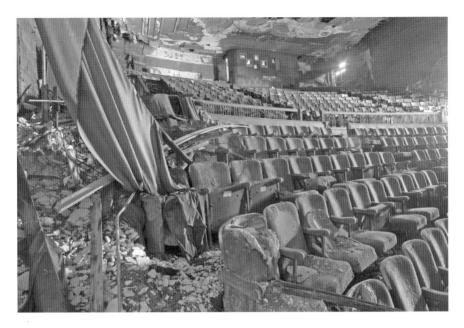

Light filters through cracks in the wall and onto the seats of the abandoned Paramount Theater. *Photo by the author.*

to open in the rapidly growing suburbs. Yet the novel world of the drive-in represented the first real threat to the downtown movie houses.

The widespread affordability of automobiles allowed for the dispersal of the population outside the urban core, and the drive-ins very much appealed to a new car-crazy generation. The Youngstown Drive-In (later renamed the Southside Drive-In) opened in 1947 in a rural section of Boardman. It was followed a month later by the Sky-Hi Drive-In in Coitsville. The new world of the suburban cinemas came later. First built into plazas and then later malls, theaters like the Boardman Plaza Cinema and the Liberty Plaza Theater offered none of the grandeur of the traditional downtown movie house or, in some cases, even the traditional neighborhood theater. Yet these new theaters were conveniently located in popular plaza shopping centers, and as time passed, modern suburban theaters came to offer a wide variety of features on multiple screens.

At the end of the 1940s, the city of Youngstown commissioned the Pace and Associates firm of Chicago to investigate, among other things, conditions in the central business district. Much of the nightly business activity at that point came from theaters. Pace discovered a significant drop-off in downtown parking demand between 1946 and 1951. The firm

THIRD PLACES

blamed the decline on the rise of drive-in theaters, new theaters outside the central business district with large numbers of parking spaces and the rapid spread of the popularity of television.[73] All of these factors brought down the great movie houses in the 1960s. It was announced in late 1964 that the nearly forty-year-old Palace Theater would be torn down to make way for an enclosed mall and a Cinerama theater dubbed the "New Palace Theater." (Instead, the Palace became a parking lot.)

Not long after the Palace's date with the wrecking ball, the Paramount hosted one of its largest galas in years. In February 1966, local movie star sensation Elizabeth "Biff" Hartman returned to Youngstown for the premiere of *A Patch of Blue*. Hartman's standout performance as young blind woman discovering the world for the first time garnered her an Academy Award nomination, and at the age of twenty-two, she was the youngest Best Actress nominee in Academy history at that time. Hartman's career began after she started performing at the Youngstown Playhouse. Eventually, her early work led to roles at the Kenley Players and the Cleveland Playhouse. After a short turn on Broadway, Hartman landed a dream role aside Sidney Poitier that made her a star.

The premiere captured the entire city's attention. *Look Magazine* dispatched Louis Schmidt (a Rayen School graduate) to spend several days covering Hartman's visit. Searchlights and throngs of Youngstowners were on hand on opening night as Jack Hynes escorted Hartman into the Paramount Theater. Mayor Anthony Flask presented her with a plaque honoring the event. She replied, "This is undoubtedly the most exciting night I shall have in my entire life, because of you, my family and friends, those who have always meant the most to me, are sharing my happiness."[74] The Paramount and downtown returned temporarily to the grandeur of an earlier time.

In 1967, the Paramount prepared for another grand reopening. The theater underwent the necessary conversions to show 70mm films, which included a complete upgrade to six-track stereophonic sound. The reopening also included new carpeting, repairs to the marquee and a new opening curtain. Flowers were given to all the ladies who attended the opening night film, *Grand Prix*, starring Eva Marie Saint and James Garner. The new 70mm films quickly drew audiences to the theater. In 1968, the 70mm debut of *2001: A Space Odyssey* received a stellar premiere at the Paramount, and reserved seating only predominated during the film's two-month run.

Yet even as the Paramount seemed to prosper, downtown theaters continued to go dark. In 1968, the vaunted Warner Theater closed its doors; two years later, the State Theater shuttered. The Paramount remained the

LOST YOUNGSTOWN

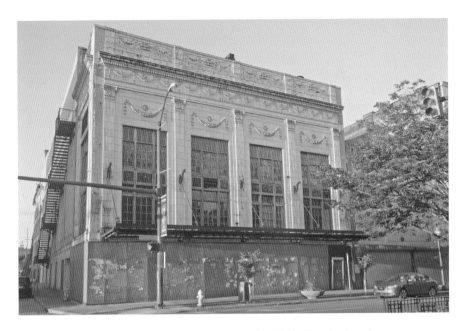

The boarded up Paramount Theater as it appeared in 2011. *Photo by the author.*

last functioning movie house downtown in the summer of 1970—but not for long.

The Paramount closed temporarily in late 1970 after showing *The Strawberry Statement*. It reopened again, only to close once more in May 1971. For the first time since the beginning of the century, downtown offered no active theaters. Yet the Youngstown area suffered no shortages of places to see films. The *Youngstown Vindicator* listings actually grew between 1950 and 1970.[75] However, the growth in theaters in the outskirts came at the expense of those downtown.

In the summer of 1973, the Paramount reopened under the management of VP Properties, a division of University Circle Property Development in Cleveland. The slogan "Movies are in Downtown Youngstown!" accompanied the theater's advertisements. Management announced a policy of showing films geared toward children and the new genre of black cinema. In particular, blaxploitation and martial arts movies dominated the theater's offerings. Not only did blaxploitation films help struggling studios, but they also helped jumpstart fading downtown movie houses looking for audiences.[76]

Opening night featured Tamara Dobson ("She's 6 Feet 2 inches of dynamite!") in *Cleopatra Jones* and Bruce Lee in *The Chinese Connection*. The Paramount ran eight showings daily with two different films; Fridays and

THIRD PLACES

Saturdays featured midnight movies. Audiences crowded in to pay a dollar to see films like *Coffy*, *Cooley High*, *Enter the Dragon*, *Foxy Brown* and *Miss Melody Jones*.

"I started going in 1973, and by that time, it had become sort of a grindhouse," explained James Moore, a Paramount regular. "You could tell it at one time was a grand movie palace. But the ceiling of the lobby was peeling, and you could tell the theater needed at least a fresh coat of paint." Tonya Martin was among the many from the Oak Hill area to frequent the theater after it reopened. "Every Sunday, I would walk down from the south side with my cousin," she recalled. "The snacks were really cheap, and it was just a really wonderful place to go." The Paramount, however, still faced fierce competition and, as the decade wore on, a downtown with less and less commercial traffic.

Even within its targeted genre of movies, the Paramount competed with drive-ins, like the Sky-Hi and the Super 45 in Warren, which also featured exploitation films. In late 1975, a confrontation between police and patrons outside the Paramount became one of the top stories in local media for weeks. Amid the negative publicity, the theater unceremoniously closed at the end of 1975. *Let's Do It Again* with Bill Cosby and *Take a Hard Ride* with Jim Brown were the last features shown. For several years after, the theater sat in silence with only a bakery and a confectionary left in the adjoining storefronts.

In 1983, a partnership formed between Richard Blackwell, roofing and siding contractor, and Bill Andrews, a would-be historic preservationist. Both men shared a passion for some of the forlorn gems in Youngstown's rotting downtown. Blackwell hoped to try to spearhead an effort to save the old Baltimore and Ohio rail station, the last house in the Wick Oval area, the Fraternal Order of Eagles Hall and the fading Paramount Theater. The duo soon purchased the Paramount and initiated a public fundraising effort to restore the building. The timing seemed right. The Youngstown Revitalization Foundation had already begun an effort to obtain grants to begin the first-ever historical survey of downtown.

The partners bought the Paramount for $50,000; individuals and local companies donated construction materials and some cash. Andrews hoped to turn the Paramount into an art theater. "This is what will bring people downtown. They just need a reason. It's happened in other places, why not here?"[77] But the road ahead for revitalizing the Paramount proved harder than the duo imagined.

It might have seemed an opportune time to try to reopen the Paramount. "At the time I first became interested, there was still vitality downtown," Bill

LOST YOUNGSTOWN

Andrews recalled. "Higbee's was still downtown; Strouss was still downtown, and Lustig's and Livingston's." Two other business partners purchased the old State Theater with plans to turn it into a live music venue once again.

In October, the Paramount opened to the public for tours. Community interest seemed high. In February 1984, the theater received a designation on the National Register of Historic Places; it remained the oldest standing theater in northeastern Ohio. Yet the two men could obtain no assistance from the city, and no investors seemed to be forthcoming. Two tenants, Giannio's Candies and the Gondolier restaurant leased storefront space, but with mounting bills and no end in sight, Blackwell and Andrews held an unsuccessful auction, which featured the theater's original organ, to raise money.

In December, the theater admitted patrons for the first time since 1975. "Youngstown Sheet and Tube Days" featured old documentaries of the steel company for two dollars admittance. The cost of bringing the old projectors up to code was far too high, so they showed 16mm films. The university rented out the theater for a Halloween party, and the Afro-American Cultural Society held a variety show; however, things soon stagnated. Once again, the Paramount was for sale, and Blackwell and Andrews walked away.

The Paramount Theater was torn down in 2013. A structure containing a pilaster made from the theater's terra cotta stands on the site of the former movie house, which currently is a parking lot. *Photo by the author.*

THIRD PLACES

"It was a different time, and maybe we were premature in attempting to do something like that," Andrews later said.

The Paramount changed hands several times before the city took possession of the theater. By 2010, the remains of the theater stood encased in life-size photographic murals depicting the downtown of yesteryear. Two years previous, local activists managed to save the façade of the condemned State Theater from the wrecking ball. A similar effort entitled the "Paramount Project" got underway in 2012. This nonprofit group envisioned a preserved Paramount façade with a common space or amphitheater behind it. Instead of an empty lot, downtown would have a multipurpose community space in a business district bereft of good public spaces.

However, after a feasibility study revealed that preserving the façade would be cost prohibitive, the Paramount ended up on the demolition list. Contractors pulled down the once grand building in 2013, and the Paramount Theater joined the long lost Palace Theater as a parking lot. But the Paramount remains in the memory of generations of local moviegoers, and the quiet corner on West Federal awaits a new purpose in a slowly revitalizing downtown.

4
UPTOWN

The giant letters of the old Uptown Theater stand like solitary lookouts over the din of traffic on Market Street. Below the blank marquee lies a lost world. While commuters still regularly course by the faded corner at Market and Indianola, few pause to consider their environs. No longer do fashionably dressed couples and families glide passed storefronts, ready to take in a show or a meal; no glittery neon signs greet those looking for a night on the town. The term "Uptown" might seem to have little relevance today, yet at one time, it served as the heart of the south side. But as the neighborhoods around it declined, so, too, did the economic engine of Market Street. Although the business corridor is long gone now, few will forget classic Uptown establishments like the Colonial House, Mr. Wheeler's, the Uptown Theater and the Cave. That history, and the story of the efforts to revive the Uptown as its glory days faded, remain relevant today as Youngstown continues its revitalization efforts.

As the city celebrated the end of the nineteenth century, the area south of downtown across the Mahoning River seemed like a world away. In the years before the Civil War, the only paths south across the river were covered bridges located at Spring Common and Presque Isle Street near the present-day South Avenue Bridge. By the 1870s, a small floating bridge existed for pedestrians looking to cross from downtown to the foot of "Impassable Ridge," as the bluff on the other side was referred to. In 1899, the Market Street Viaduct opened. For the first time, a reliable way of moving people and materials to the expansive land to the south had emerged.[78] The Park

THIRD PLACES

The Uptown Theater's long-abandoned marquee remains a fixture in the Uptown area. *Photo by the author.*

and Falls Street Railway Company, organized in 1893, soon provided accessible transportation to facilitate development of the south side. The company's backers also organized Terminal Park (later known as Idora Park) at the terminus of the streetcar line in the old mining town of Fosterville. Market Street, however, emerged as the center of commercial activity as the south side flowered.

Only a few hundred homes dotted the largely rural area around Market in 1900. Yet within fifteen years, thirteen churches, seven schools and voluminous numbers of new residences sprouted up in the area.[79] In 1912, the business district stretched from the viaduct to the intersection of Market Street and Marion Avenue. A plethora of grocers, druggists, confectioners and dry cleaners operated, and individual proprietors usually lived above their storefronts.[80] South High School was built in 1909. South Side Bank opened its doors in 1915, and Stambaugh-Thompson debuted its Market Street location in 1928. The first South Side Library branch appeared a year later.

The South Side Merchants and Civic Association formed in 1930 as the Depression began to darken the city's business climate. Designed to promote businesses on Market Street and throughout the area, the SSMCA formed

the first "South Side Day," which annually brought thousands out for a long parade down Market for the crowning of Miss South Side at Idora Park. By the end of the 1930s, the south side (from the Mahoning River to Midlothian Boulevard and from Shirley Road to Glenwood Avenue) consisted of seventy thousand people and twenty-five thousand homes.[81] This spectacular growth fueled the creation of what came to be called "Uptown."

A consensus never fully developed about how much of Market Street constituted Uptown. However, the heart of the commercial district came to be viewed as the intersection of Market Street and Indianola Avenue. For years, the intersection (known as Kyle's Corners) marked the edge of "town." In 1937, a large block of commercial buildings was erected at the corner of Market Street and Hylda Avenue. Woolworth's five-and-ten and a Kroger grocery store quickly leased space on the block. Commercial buildings already occupied the west side of the street, and this new stretch of block was viewed as the next big step in the Uptown district's evolution.[82] A large-scale lighting system made the area's nightlife possible by the early 1940s, sparking further business growth.

After World War II, city planners and developers eyed the area between Market and Hillman Streets as the spot for a future shopping center dubbed Mar-Hill Markets. It is possible that Mar-Hill could have shifted the locus of commercial activity away from Uptown; however, a planning board of appeals permanently halted the project shortly after construction began.[83] Instead, Uptown continued to prosper, spawning some of the most memorable and sometimes notorious establishments in the city.

One of Youngstown's most magnificent eateries opened not far from the corner of Market and Indianola in 1948. Built inside an old Colonial Revival mansion left over from the early twentieth century, the Colonial House restaurant projected a palatial elegance. Over the decades it established a reputation as a restaurant that catered to higher-end customers.

According to Attorney Alan Kretzer, "At one time, the Colonial house was the place to go, especially for the type of professional that you wouldn't find at the Youngstown Club, where the membership typically consisted of steel executives and people in banking. The people who went to the Colonial House often were people with money who were looking for very good food."

A variety of different ethnic groups also frequented the Colonial House. "The Colonial House was an Irish institution," former judge Patrick Kerrigan remembered. "You couldn't sit in the place on St. Patrick's Day; every Irishman worth his salt was there."

THIRD PLACES

The former Colonial House restaurant, once a residence in the early twentieth century, was one of the most popular restaurants in the Mahoning Valley for nearly fifty years. *Photo by the author.*

The Colonial House's early years were often dominated by publicity centering on the restaurant's owners, especially James Vincent DeNiro. An East High graduate and World War II veteran, the dapper and dashing DeNiro began his climb up the local mob ladder not long after the war. Success came fast and furiously. DeNiro ran the largest "bug" (the local euphemism for the illegal lottery) operation in Mahoning County, and during the 1950s, he also operated an illegal casino known as the Dry Men's Social Club in Coitsville Township. It became the largest betting parlor in Ohio and Pennsylvania. Described as a "miniature Jungle Inn" (referencing the infamous former casino in Trumbull County) by the *Youngstown Vindicator*, the Coitsville casino operated under the protection of the Mahoning Country sheriff and local law enforcement.[84]

Originally, the Colonial House was designed to have gambling upstairs, but the Charles Henderson administration, which had run on a platform of "Smash Racket Rule," made that too difficult for DeNiro and his partners. The political winds, however, changed after Henderson left office in 1954. Before announcing his candidacy for mayor in 1956, municipal judge Frank Franko denounced the city's own vice squad, claiming that it acted as

protection for Vince DeNiro and the "Colonial House clique."[85] Indeed, the men behind the restaurant seemed to pull a lot of weight in local politics and in the underworld. DeNiro's partners in the Colonial House—reputed bug operators Carl Rango and Frank Fetchet—also became his partners in the National Cigarette Service Company after he bought out Anthony "Tony Dope" Delsanter, who later became the consigliere of the Cleveland Mafia.

Police picked DeNiro up for questioning at the Colonial House after the bombing of Democratic Party chairman Jack Sulligan's home in 1954. That same year, a bomb exploded at Frank Fetchet's north side home. Local investigators later believed DeNiro to be behind the rash of bombings; in any event, an apparent fallout between him and Fetchet led to DeNiro's exit from the Colonial House and then opening of one of Uptown's most acclaimed restaurants.

In 1959, just down the street from the Colonial House, Cicero's restaurant opened in the former location of Burton's Grill. In short order, it established itself as "what many considered Youngstown's most glamorous restaurant."[86] Local police and newspapers soon pointed to a brewing "Uptown feud" between DeNiro and the Colonial House as news of the restaurant's opening spread.

DeNiro spared no expense on Cicero's, hiring designer Victor Kosa to help fashion the restaurant's noteworthy interior. Kosa once owned the building that housed DeNiro's "miniature Jungle Inn" during the 1950s. During one particular raid on the suspected casino, police found Kosa inside the building calmly working on signage; he didn't even look up to acknowledge the officers.[87] Kosa was also a master craftsman, however, and, along with Edward Cochrane—who remodeled DeNiro's Dry Men's Social Club—turned Cicero's into an upscale eatery par excellence. Cicero's also became a prime dancing spot in Uptown, along with competitors like the Tropics and the Mansion. Eventually, management brought in acts from the club circuit in Las Vegas, Miami and New York. But within two years of its opening, Cicero's became the scene of one of the most spectacular gangland assassinations in Youngstown history.

The decade between 1950 and 1960 spawned seventy bombings in the Mahoning Valley linked to the local underworld. Homes, businesses and cars of suspected mobsters and local businessmen—even public officials—exploded or were damaged by incendiary devices and acid-based bombs with regularity. Police suspected a group of for-hire bombers dubbed "Dynamite Incorporated." These freelance bombers were hired to send "messages" to targets of the local underworld. As the

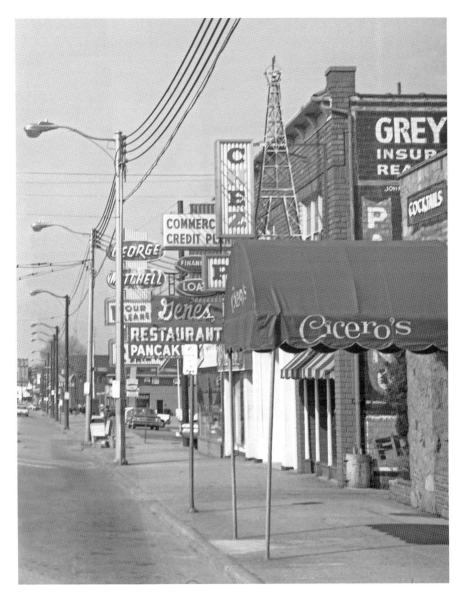

Vince DeNiro's Cicero's restaurant attracted everyone from families to gangsters during its ten-year existence. *Courtesy of Mahoning Valley Historical Society.*

explosions became more deadly, the car bomb emerged as the weapon of choice. Popularly referred to as "Youngstown tune-ups," these terrifying means of targeted assassination led back to Cicero's and one of the most infamous events in Youngstown and Uptown history.

LOST YOUNGSTOWN

Gangster Vince DeNiro was killed in a spectacular explosion across from Cicero's in 1961. This is the location of the bombing as it appeared over fifty years later. *Photo by the author.*

On July 17, 1961, Vince DeNiro departed this world in an enormous explosion that rocked Uptown for blocks. Just after midnight, he turned the key to his Oldsmobile convertible outside Cicero's, triggering a bomb that packed the explosive power of ten sticks of dynamite. The detonation blew windows out of storefronts up and down Market Street. One of the car's tires ended up seventy-five feet away in the storefront of George Yates and Sons; the fender was found inside Fron's Candy Store. Like macabre Christmas ornaments, parts of the Oldsmobile dangled from overhead power lines. Thousands gathered on Market Street to witness the aftermath, although luckily no one except DeNiro was killed or maimed in the explosion.

DeNiro's murder ushered in the beginning of the next brutal phase of the war for Youngstown's rackets, but it had little long-term effect on the popularity of Cicero's, which thrived until it burned to the ground in 1969. Nor did it really affect Uptown. It would be eighteen years before a heinous crime challenged the district's future.

Only a few storefronts away from the Colonial House and Cicero's, Mr. Wheeler's emerged as an example of one of the smaller restaurants that came to define Uptown's classic eateries. Mr. Wheeler's sandwich shops actually started out as a regional chain. Businessman Ralph Wheeler organized the

THIRD PLACES

first Mr. Wheeler's in Warren during the early Depression years, and stores soon opened in East Liverpool, Warren and New Castle, Pennsylvania.

In Youngstown, two Wheeler's locations had opened by 1938—one at the corner of Market Street and Indianola Avenue and the other on Market Street next to Dollar Bank across from Stackhouse Oldsmobile. Wheeler sold the Youngstown locations to Carl Yacol shortly before the start of the war. The Yacols eventually turned over the managing of the Market and Indianola location to Carl and Marjorie Jones, who also managed the Borden's Dairy in Boardman. The Jones family acquired both locations after Yacol retired to Arizona.

Both Mr. Wheeler's restaurants were modest setups with cafeteria-style service, but they developed a hardcore following. Customers entered and stood in line with a tray to place their orders. "On that tray they would make most interesting short-order cook type markings on wax paper, symbolizing what you ordered," playwright Rob Zellers remembered. "As you stood there, you could look right into the back kitchen, which always fascinated me." From that kitchen came a delightful assortment of French fries, milkshakes, soups and sandwiches.

Mr. Wheeler's was particularly known for its macaroni and cheese and the famous "Topper" burger. "My dad had good-quality meat," recalled Cathy Reuter, who worked with her parents until her sophomore year in college. "He ground his own meat, and he had his own special process. Eventually, he got a butcher to make his hamburger for him." Starting every morning, customers could stop in for homemade doughnuts, coffee, eggs and bacon. Lunches featured soups of the day, hot dogs and grilled cheese sandwiches, which proved especially popular with the Catholic lunch crowd on Fridays. During the height of Uptown's popularity, Wheeler's stayed open until midnight to accommodate the late-night crowds.

By the 1950s, crowds increasingly and regularly flocked to establishments like Mr. Wheeler's in Uptown. In 1957, planners noticed the district continued to siphon off large numbers of shoppers from downtown.[88] That same year, the Uptown Businessmen's Association formed to help further promote the expanding area. In 1956, the strongest sign yet of Uptown's rise came with the opening of a Sears near the corner of East Hylda Avenue and Market Street.

The two-story brick-and-metallic-trim structure featured a mostly glass first floor that highlighted displays visible from the street. The nearly fifty-five thousand square feet of sales floor featured everything from hunting and sporting goods to interior lighting needs. Color-coordinated departments

LOST YOUNGSTOWN

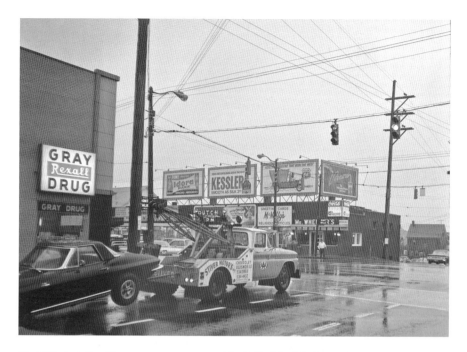

Mr. Wheeler's first Youngstown store opened in 1938. The Market and Indianola location (pictured here) became one of the most popular eateries on Market Street. *Courtesy of Mahoning Valley Historical Society.*

designed to suggest certain moods were complemented by mood music featuring everything from classical to rock-and-roll. A snackette counter served both employees and hungry shoppers.

The new Sears became a prime shopping destination. The company understood from an early date that shoppers sought ready access to parking—something many downtown stores struggled to accommodate—and the Market Street Sears provided over five hundred spaces. Increased parking also brought increased traffic from the growing population just to the north in Boardman.[89] However, Uptown remained an urban environment, primarily catering to pedestrian shoppers from public transit and from the densely populated surrounding neighborhoods. "The neighborhoods around Uptown were crowded with people, and kids were in almost every house," Patrick Kerrigan explained. "As kids, we thought nothing of going up and leaving our bikes in back of Sears and going in and then cruising Uptown. Our bikes were always there when we came back."

Night life also thrived. In 1963, not far from the corner of Pasadena Avenue and Market Street, one of the city's quirkier and more popular establishments

THIRD PLACES

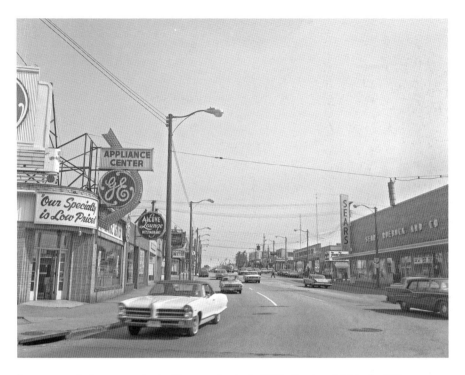

Sears opened a large store in the Uptown district in 1956. *Courtesy of Mahoning Valley Historical Society.*

opened its doors. Patrons who walked into the Cave Lounge entered a unique atmosphere that channeled *The Flintstones* and featured a stalactite-covered ceiling crafted from papier-mâché. The brainchild of Leander Quaranta and his two brothers, Ron and Edward (who previously operated Lee and Eddie's Lounge in Uptown), the Cave attracted a loyal following. The lounge's mood lighting emphasized the cavernous environment, with the lavender chairs and purple carpeting blending in seamlessly. The stalactites and stalagmites came from the deft touch of Poland's Rob Johnson, who honed his craft in Germany while in the service. According to Ron Quaranta, "It was a plush cocktail lounge at a time when Market Street was a strip of restaurants and bars."[90]

The Cave originally served some Italian fare but also featured steaks and sandwiches. However, the lounge was primarily known as the perfect spot to dance, carouse and take in the music of local bands and performers like Brotherhood and the Left Bank Trio. Go-go dancers became all the rage on Market Street during the 1960s, and the Cave featured its fair share of lithe ladies. In 1975, the Cave closed and reopened as Lewardo's, a gourmet Italian restaurant.

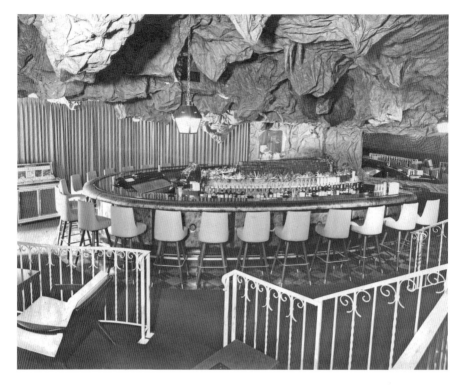

The elegant Cave Lounge became a top Uptown attraction during the 1960s. *Courtesy of Anna M. Quaranta.*

The named derived from the combination of Leander's (Lee) and Edward Quaranta's names. A slightly dress-downed Cave atmosphere (still featuring the stalactites) remained, but the new restaurant featured the skills of chef Joe Rotundo and Jerry Quaranta, who catered to the adventurous tastes of Lewardo's regulars. Neapolitan-style dishes and homemade recipes—which were later featured in *Gourmet*—helped propelled the restaurant into the top ranks of Uptown eateries until the restaurant closed in 1980. The Cave reopened eventually in the same location as JJ's Cave, surviving into the early 1990s.

Few places on Market Street lasted as long or became as emblematic of Uptown as Mickey's Bar. Even after owners Anne and Russell "Mickey" Williamson sold off their legendary establishment in the 1970s, new owners traded on the Mickey's name for years. Mickey's Bar represented Youngstown's vibrant tavern life as well as any place in the city, and visiting it became a rite of passage for those who enjoyed Market Street's night life.

THIRD PLACES

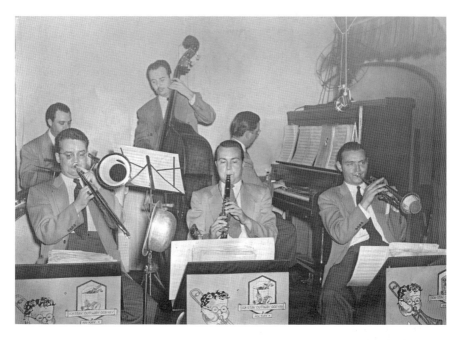

Mickey Williamson (playing the trombone) is pictured at the original Mickey's location on Mahoning Avenue. *Courtesy of Gerryanne Thomas.*

Although Mickey's became an Uptown landmark, the bar itself originally opened on Mahoning Avenue near the end of the Depression. The original Mickey's became a prime venue for live entertainment on the West Side during a time when a wide variety of live music venues thrived, like Club Trocadero and the Torch Club. Bands from as far away as Pittsburgh and Akron came to the bar to jam, and Mickey (an accomplished trombone player and former touring musician) often joined in.

After Mickey's service in the war, he returned home to find that the music scene had changed wildly. Facing declining business, the Williamsons moved the bar to the corner of Market Street and Hylda Avenue in the rapidly expanding Uptown district. Mickey's reinvented itself and brought in house acts like Ronnie Rose and Hal Greene. The new venue and musical lineup drew in large crowds, which often stretched down Hylda. "My mother was a master of reinventing Mickey's," remembered Gerryanne Thomas. "She knew how to pick up the business when it hit downturns."

Originally the tavern featured a somewhat extensive menu. Its offerings featured spaghetti with meatballs or mushrooms, broiled lobster tails, breaded veal cutlets, baked ham and T-bone steaks. Over time, the menu

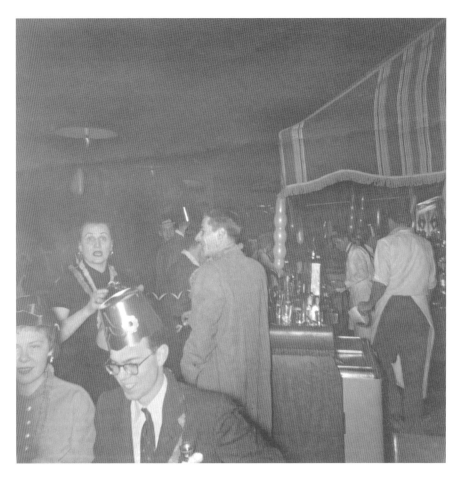

Annie Williamson (standing) is pictured at Mickey's Bar in Uptown in 1953. *Courtesy of Gerryanne Thomas.*

was phased out entirely. After going years without serving much food, Annie began to realize that the bar needed something for patrons to munch on, which led her to develop the famous Mickey's cheeseburger. Made in a small kitchen space not much bigger than a restaurant booth, the mouthwatering burgers served as the perfect answer for hungry drinkers.

Mickey's changed with the music scene over the years. When rock-and-roll took off, the Williamsons brought in new acts. Future superstars Maureen McGovern and the Raspberries both played the bar. Perhaps the most popular band to play Mickey's during those years was the Human Beingz, who scored a hit in 1967 with their cover of "Nobody But Me." The group

ultimately got its big break at Mickey's, when a talent scout came to town on a night when the band had nowhere to play.

"The only night the scout was going to be in town was a rare Thursday night off for us," vocalist and guitarist Joe "Ting" Markulin recalled. "We approached Anne and Mickey about doing a special show—free of charge—in order to have a venue for the scout. After the show, the talent scout took us back into the little kitchen at Mickey's and said, 'I'm going to go back and get you signed on Capitol Records.'"

Mickey's remained a popular destination well into 1978, when the Williamsons finally sold the bar and retired. Yet Uptown's reputation suffered during the 1970s. While the Market Street corridor lured away business from downtown in the 1950s, new plazas and suburban shopping outlets began to attract shoppers away from Uptown as early as the 1960s. The fear of crime accompanied spreading blight in the neighborhoods around the district. Those fears came true after a tragic murder rocked Market Street and the city in 1979.

In early June, after a series of rapes in the area, twenty-year-old Elaine Poullas was found murdered in Mill Creek Park after being reported missing from her car in front of the Beachcomber on Market Street. The city immediately opened a police substation in the area, and an influx of beat cops began patrolling Uptown nightly on foot. But Market Street's reputation had already taken as serious hit. "Market Street has gone down by leaps and bounds," remarked attorney Sam Fekett in 1981. "Something is going to have to be done, because it's just becoming a slum area."[91]

The city responded by trying to give Uptown a facelift: abandoned storefronts were demolished and landscaped, brick sidewalks replaced cracked concrete and storefront façades were updated or replaced with a combination of public and private funding. Planners even proposed a "festival mall" concept for a former Kroger store near the corner of East Laclede Avenue and Market Street. All eyes focused on Uptown. Businessman Ron Chambers summed up the feelings of many when he remarked, "What happens to Market Street is going to happen to the city."[92] Yet an unlikely theater troupe working from a repurposed movie house, not city planners, brought an unexpected resurgence to Uptown as the decade ended.

The Market Street Theater was the first theater in the corridor when it opened in 1914. The Rialto Theater came a few years later at the corner of Myrtle Avenue and Market Street. In 1926, the $126,000 Uptown Theater opened in the heart of the commercial strip. Unlike its predecessors, the Uptown survived the Depression and emerged as one of the most popular

LOST YOUNGSTOWN

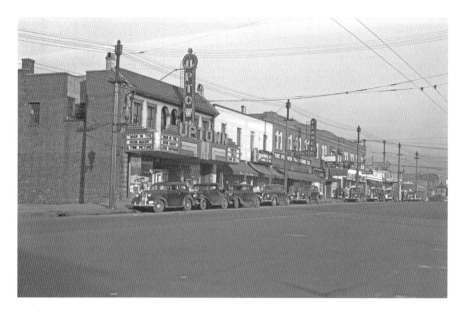

The Uptown Theater opened on Market Street in 1926. It was built with a small balcony and originally featured a Robert Morton pipe organ. *Courtesy of Mahoning Valley Historical Society.*

movie houses in the city. The theater, which could seat 650 patrons, resembled a large neighborhood theater from the street, but its Robert Morton pipe organ and interior and exterior fineries made it a suitable establishment for the rising Uptown district.

Stephen Foster and Peter Wellman obtained the Uptown Theater in 1948. Wellman was intimately involved in the local theater business and had just opened the Belmont Theater. Foster cut his teeth in Canadian vaudeville before leasing the Schenley Theater on the west side. The Uptown became known for showing double features during their tenure, and it catered to a loyal south side crowd as well as suburbanites in Boardman. "The Uptown Theater billed itself as 'Youngstown's luxury theater,'" local historian Richard Scarsella remembered. "They even took reservations for certain movies."

The Foster family took sole control of the theater in 1955, and the Uptown underwent an elaborate interior and exterior remodeling in 1965, which made the cover of *Box Office Magazine*.[93] Seats were widened (reducing seating capacity to five hundred) and a new interior lobby constructed. The theater curtain and the walls were covered with a floral pattern design. *Von Ryan's Express*, *Jesus Christ Superstar*, *The Sting* and *The Graduate* (which played from February to October 1968) were among the big hits of the era at the Uptown.

THIRD PLACES

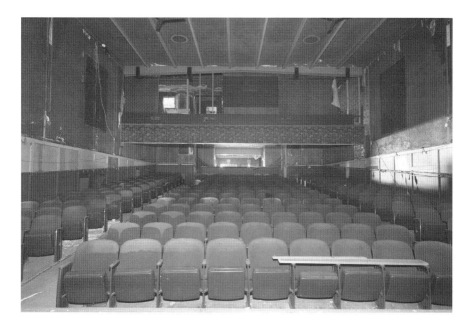

The now closed Uptown Theater as it appeared in 2015. *Photo by the author.*

The theater enjoyed widespread popularity throughout the 1970s. The 1975 screening of *Jaws* brought capacity crowds for sixteen weeks straight. "Sensurround" was installed for the showing of disaster flicks like *Earthquake*, *Rollercoaster* and the war drama *Midway*, and a regular series of blockbusters continued to draw patrons. The Fosters sold the Uptown to Cinemette Corporation of Pittsburgh in the late 1970s. But the theater declined under Cinemette's ownership heading into the 1980s.

By 1986, the city considered the Market Street commercial corridor a priority redevelopment area. The Uptown Theater stood roughly in the center of the development zone. The city extended a loan to businessman James Wilcox in late 1986 to buy the Uptown before it was turned into a pornographic movie house like the Foster Theater. The hope was that if the Uptown could remain solvent, then perhaps it could help revitalize the fading strip.

Wilcox came to the Uptown with high hopes; he imagined the theater blossoming into an anchor for redeveloping the strip into something akin to the Coventry Village shopping area in Cleveland Heights. He initially competed for first-run movies but soon found it too expensive. Instead, the Uptown took to showing second-run double features. Even that policy failed, however, and Wilcox rechristened the Uptown as an art house theater.

LOST YOUNGSTOWN

For a brief period, it attracted a strong college crowd and a loyal audience looking for films that normally only screened in Cleveland or Pittsburgh. Yet the Uptown's continually shaky finances forced Wilcox to finally close. Only months later, a popular theater group named Easy Street Productions moved into the Uptown and converted it into a live theater. It turned out to be the beginning of a local revitalization movement.

Maureen Collins and Todd Hancock returned to Youngstown from Los Angles in the 1980s as part of a stopover, intending to then make their way to New York City. Along with some local actors, they decided to put on a show dubbed *429 Miles off Broadway* while they were in town at the Oakland Center for the Arts. One segment of that show, called Pump Boys and Dinettes, proved so popular that they decided to put on the entire Pump Boys show at the Oakland. While looking for a more permanent place to perform, Hancock received a tip about the then dark Uptown Theater. "I remember pulling up in front of the Uptown, and I just sat there looking at it," Hancock recalled. "In my heart, I just knew it would work."

Within a month, Easy Street Productions, as they called themselves, relaunched Pump Boys in the new venue. It became the longest-running musical show in Youngstown history when production wrapped in the summer of 1991. During that time, a local revival grew around the theater. James Wilcox's Chester's restaurant catered to the large groups coming out of Easy Street's nightly shows. The Chez Lounge, the Troubadour, the Jambar, the Blue Note Café and Frankie's Beach Bar attracted a new crowd coming into the Uptown. Even old favorites like Foy's Barbeque, the Colonial House and Mr. Wheeler's enjoyed increased business.

The upturn in the area's fortune also buoyed the Oven restaurant, located on Southern Boulevard, which had long attracted a loyal following. Opened in 1960 as the Pizza Oven, the establishment's roots actually extended to Colorado, where Robert Parella opened the first restaurant.[94] "It was one of the first restaurants in the city to be open until around midnight," Richard Scarsella recalled. "They were also the first restaurant in the area that was not only upscale Italian, but also fast-casual. And they pioneered the personal pan pizza. Pizza was not popular in those days…No one had heard of a personal pan pizza, but it became very popular, especially with high school kids after football games at South High."

Many of those crowds began to return to the Oven as the popularity of Easy Street brought in increased traffic. "I think we are a bright spot in the community," owner Robert Parella remarked at the time. "It's familiar, like we are part of the family."[95]

THIRD PLACES

The former Oven restaurant prominently featured personal pan pizza as a prime attraction in the years before the ubiquity of delivery chains. *Photo by the author.*

The Colonial House restaurant continued to thrive into the 1980s, even as Youngstown's tradition of fine dining faded. In 1989, only months after Easy Street started performing at the Uptown Theater, businessmen John Ridel and Robert Van Sickle took over the Colonial House from the Lyden family, who had run the restaurant since the death of Carl Rango in 1971. Rechristened as "Colonial House II," the duo sought to cement the restaurant once again as the finest in the valley. After a fire destroyed the Mansion restaurant in 1984, few Youngstown restaurants remained with a dress code. However, the Colonial House II continued to cater to a business and evening crowd that demanded quality service and established etiquette.

Well-known chef Jeffrey Chrystal was brought in to serve as head chef and general manager. Chrystal planted an herb garden on the premises and prepared everything from scratch. "Our bartender would have the same cocktails ready in a line for the same guys who came in for lunch everyday," Chrystal said. "At 4:30, I'd put hors d'oeuvre on, and just about everyone showed up: top businessmen, the mayor, doctors, attorneys, everyone at the top echelons of Youngstown came to the Colonial House." The Easy Street crew also occasionally visited the Colonial House after a sold-out show to sing a song for the crowd. Uptown appeared to be back on the upswing.

LOST YOUNGSTOWN

The district represented one of the last bastions of nightlife in the city by 1992. Yet problems brewing between Easy Street and James Wilcox led to the theater company's departure in 1994. Traffic for businesses on Market Street dropped off substantially within a short period of time. The neighborhoods around the Uptown had already become the poorest in the city, and rising crime and a loss of momentum left the Uptown district clinging to life by the end of the decade.

After the Colonial House II closed, William Umbel, who also ran the Pyatt Street Diner, tried for a time to return the restaurant to its former glory. Mr. Wheeler's continued under a succession of owners before eventually closing. The Oven struggled until it finally closed, becoming the Jamaican Oven and an Isaly's Busy Bee for a short period of time. Some businesses in Uptown soldiered on. Several clubs, usually catering to the eighteen-to twenty-one-year-old crowd, survived for several years. "There was a bit of resurgence, but not a good one," south side resident Donald Attenberger later remembered. By 2008, few businesses remained in Uptown.

Today, Youngstown's downtown has begun to revitalize. Just to the south, the once crowded Market Street corridor awaits future plans. The old Colonial House and the former Uptown Theater still stand, waiting for their futures to be decided and for the next chapter in the city's history to be written. While it remains unlikely that Uptown will return to its heyday, the memories of the past still inspire a variety of south side stakeholders aiming to revitalize what was once the most populous area of the city.

5
THE (NU) ELMS BALLROOM

As the first leaves of fall make themselves visible, students at Youngstown State University stroll passed the Kilcawley Center in the center of the campus, headed perhaps to the Cafaro House or the Watson and Tressel Center. Unbeknownst to them, a neighborhood once existed in the midst of what is now a university. Well-manicured houses, neighborhood businesses and one of the most heralded ballrooms in the Midwest once stood at the heart of the lower north side. Fifty years earlier, the final show ever at the Elms Ballroom ended. As the last of the revelers departed, the bulldozers began to move in, and the curtain drew on one of Youngstown's most storied music landmarks.

The Elms Ballroom entertained generations of Youngstowners. Dance students, swing kids, big bands, the doo-wop groups and teens at the sock hops all came to the Elms. Future spouses took their first tentative steps together on the dance floor there, and the likes of Frank Sinatra and James Brown captivated audiences in front of the Elm's band shell. "Ohio's Smartest Ballroom," as it was dubbed, provided some of the most spectacular nights in musical entertainment that the city ever witnessed.

In 1921, dance instructor Raymond Bott received a permit from the city to begin construction on what became one of the most noted ballrooms in the state. The $50,000 tile-and-stucco building went up on Elm Street between Spring and Arlington Streets in September. The eight-thousand-square foot ballroom dance floor was the largest of any dance academy in Youngstown and "one of the most modern in northeast Ohio."[96] Although the layout was later altered, originally, the first floor contained a soda fountain, a

grill and several conversation rooms. On the second floor were the main ballroom, the coat checkrooms and a balcony, built above the dance floor so that parents of students or escorts could have an unobstructed view. Living facilities for the Bott family occupied the third floor. The building, however, had not been built as a dance hall. It served as a showcase facility for the Bott Academy itself and as a cultural institution designed to preserve and promote the art of classical ballroom dancing.

The first Bott Academy in Youngstown began in 1894 under the guidance of James Lorimer Bott. The family academy practiced and taught a strict from of classical dancing that proved to be very out of step with the new dances of the Jazz Age as the 1920s dawned. Raymond Bott sought to tread a line between the religious leaders who called for the abolition of dancing and the new world of jazz, which he despised. An advertisement accompanying a notice for the new academy on Elm Street summed up the Bott credo: "The dances we teach never border on the eccentric, they are made to fit into every bit of good music which is available for our dance purposes."[97]

Sister Jerome Corcoran took ballet lessons as a child at the Bott Academy; she grew up only minutes away on the lower north side. "They had quite the customer base, but it was also quite genteel," she remembered. "It didn't really cost more than the others [schools], but it did have that reputation. For tap in those days they tended to come to your house, but not the Botts—you came to them."

Many of those patrons traveled by way of the Elm Street trolley line, which began on Wick Avenue near Central Square, connected to Wood Street and then turned onto Elm. The presence of the trolley line gave Elm Street a mixed-character with both residences and businesses very near to each other. The Bott Academy became a landmark in the rapidly growing area.

The Botts held classes for men, women and children. Students could learn dances like the Charleston, the foxtrot and soft-shoe tap. Eventually, they began to hold "assembly dances" for adult couples on Tuesday and Saturday evenings, the first taste of a ballroom-like atmosphere in the academy. Raymond Bott's preoccupation with jazz, however, eventually led him out of the academy and into the local political arena. He pushed publically for a "jazz tax" in the city, which would be leveled on any establishment featuring jazz music and dancing. Bott's high profile led to his being elected president of the national Dancing Masters of America in New York City. Under Raymond Bott's leadership, Dance Masters trained dance leaders to educate the public nationwide in the "proper" form of dancing.[98] Enmeshed in his new role, Bott moved to New York and sold off his school in 1929.

THIRD PLACES

The Elm Street building passed into the hands of Frank Stadler, a man with a long history in the local dance world. Stadler built the famous Yankee Lake Ballroom, and he formed the Mandolin Club in 1902, which sought to encourage the spread of ballrooms and to help make Youngstown part of the musical circuit for the famous bands of the time. In the early twentieth century, the Southern Park Trotting Track (which later inspired the name for the Southern Park Mall) drew spectators from miles around to the races in bucolic Boardman Township. Stadler ran the nearby Southern Park dance pavilion until a 1925 fire burned the enormously popular attraction to the ground.

Stadler sold his old dance studio and reopened the Bott Academy as the "Elms Ballroom" in late 1929. The Elms opened as the era of dancing began to explode. Even the dawning of the Great Depression failed to kill the dance craze, especially locally. "Youngstown in the 1930s was known as a good ballroom dance town," Charles Carney later remembered. "We had no money, but we used to go to the dances about every night of the week…Like on Monday night, at Hamrock Hall in Campbell, you danced all night for a dime. The night to splurge was Tuesday night. Elms Ballroom, which was the

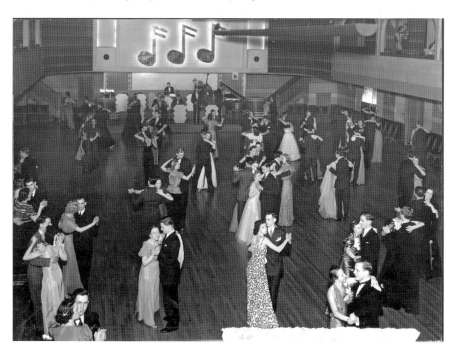

Members of the Alpha Iota Sorority dance with their partners at the Nu Elms Ballroom in 1939. *Courtesy of Youngstown State University Archives and Special Collections.*

finest ballroom in Youngstown, had 'Scotch Night,' they called it, a quarter to dance all night."[99]

Ballrooms and dance floors dotted the area: Craig Beach Ballroom, Yankee Lake, the Idora Ballroom, Krakusy Hall, the Blue Crystal in Girard, Stambaugh Auditorium, the DAV Ballroom on Albert Street and the Cascades room at the Hotel Pick-Ohio (which featured a stainless steel dance floor on the lower level). Even Immaculate Conception Church in Youngstown held dances in its basement. Knowing how to dance evolved into an important social skill.

Arthur Murray of the ubiquitous Arthur Murray dance schools offered advice for the single men and women of the era. "If you are a man, and you don't know if you will live happily with the woman who runs in and out of your mind when you should be thinking about your job, you may estimate your chances fairly accurately if you watch her as she one steps…If you think you love a man, watch his steps! Don't fear he'll be fickle, if he has abandon. But if he doesn't have it…"[100] Such was the emphasis put on dancing.

Stadler eventually divested himself of the Elms Ballroom in 1932. The Sons of Italy were using the facilities for their meetings when L.A. "Tony" Cavalier (who also ran the Idora Park Ballroom) offered to lease the Elms. The name "Nu" Elms Ballroom came into usage after Cavalier took over. The exact reason for the deliberate misspelling is a mystery today, but another ballroom (the Nu-Mart) also adopted the same moniker. Under Cavalier, the Idora Ballroom opened for the late spring and summer months, and the Nu Elms ran from September to May every year.

Cavalier expanded his ballroom business even further in 1935 when he began leasing the old H.K. Wick Mansion on Logan Road as another dance venue. The palatial fifty-four-room estate—which included an indoor fountain, a bowling alley, a large pipe organ and an outdoor terrazzo dance floor complete with band shell—became known as the "Million-Dollar Mansion." Along with the Nu Elms and the Idora Ballroom, the Mansion represented Youngstown's finest dance venues as the city entered the swing era—attracting the likes of Artie Shaw, Glen Miller and Benny Goodman.

From the time Frank Stadler took over the Bott Dance Academy, the Elms Ballroom represented one of the rare venues that regularly accommodated black audiences and musical acts. Youngstown never had a code of formal segregation, unlike the Jim Crow South. However, as the African American population increased with the Great Migration of blacks out of the South into Youngstown and other Northern cities, restrictions on non-whites became common. Many establishments, including restaurants and ballrooms, often

THIRD PLACES

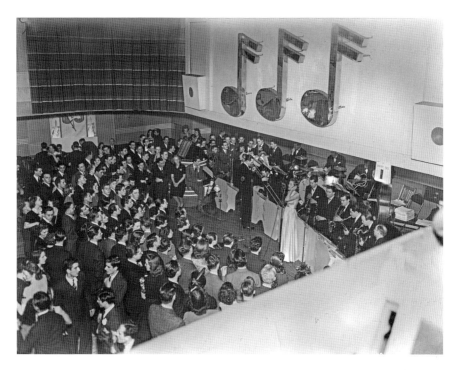

The Tommy Dorsey Orchestra plays for a capacity crowd at the Nu Elms in 1940. *Courtesy of Mahoning Valley Historical Society.*

denied service to African Americans or, in the case of most theaters, insisted they sit in the balcony only.

In the early 1930s, an organization called the Mystic Knights began hosting proms for African American graduates. "We had a dance promoter by the name of Clarence King," Rayen graduate Romelia Carter said. "He sponsored all of, what was referred to then, as our June Prom. The June Prom was designed for the black community, to pay homage to the graduates from all over the city, for the young people who did scuffle out the twelve years and graduate…My parents went to June Prom. All folks sixteen and older packed the Nu Elms Ballroom to pay special homage to those young graduates."[101]

The man behind June Prom at the Nu Elms Ballroom became one of the most notable promoters in the city. For decades, Clarence King worked six days a week as an appliance repairman at Reichart Furniture. But he established a second career as an ace promoter, bringing the nation's top acts to the Nu Elms. King's promotional career began in 1932 on East Federal Street. Along with several others, he formed the Yeah, Man Club, which sponsored local dances for the black community. The club scored some early

coups, including bringing Fletcher Henderson—widely considered to be one of the most important arrangers in jazz and swing music—to the Nu Elms. After internal disagreements broke up the Yeah, Man Club, King struck out on his own. "I didn't play [book] local bands—[only] New York's best," King later said.[102]

King's high-profile acts complemented the other top jazz and swing groups Tony Cavalier brought to the Nu Elms. The Harlem Playgirls, one of the few female swing acts, appeared at the ballroom. Count Basie played there before being fêted at the West Side Social Club after the show. The Ink Spots and Ella Fitzgerald appeared several times. Louis Armstrong played the ballroom just after his appearance with Bing Crosby in *Pennies from Heaven*, and Nat King Cole performed "Straighten Up and Fly Right" at the Nu Elms before he even recorded it.[103]

The Nu Elms was all the rage during the unique swing/big band era. According to historian David Stowe, "Swing acquired its name and gathered popular momentum during 1936 and 1937. It attracted its youthful audience through a complex media network of radio broadcasts, recordings, movies, and cross-country tours. Each year new band leaders—Benny Goodman, Artie Shaw, Tommy Dorsey, Glen Miller—rose to prominence, competing for the loyalties of an expanding audience."[104]

Former senator Harry Meshel worked as a bartender at the Million-Dollar Mansion for Tony Cavalier during the swing era. An avid dancer, he frequented the Elms on a regular basis. He danced with Dinah Washington at one of Clarence King's shows and frequented nearly all of the top dance spots of the day.

"There were very few poor dancers at the Elms, so many good ones in the crowd. Some of us were a little crazy," Meshel recalled. "We'd do the jitterbug with splits and all kinds of acrobatic moves." Dances at the ballroom attracted a regional crowd as well, according to Meshel. "You'd really get to know people, because they'd all come over to the Elms. The Akron bunch would come over, New Castle would come in, and Sharon and Farrell. It was like a big family."

The war years brought in Frank Sinatra, the Andrews Sisters, Lena Horne and other top singers. In 1946, three thousand people came to see Vaughn Monroe, then at the height of his popularity. Cavalier redesigned the inside of the ballroom after the war and expanded available parking next door. The newly remodeled ballroom (now mostly referred to as the Elms once again) celebrated its grand reopening in 1949. By then big-band music had begun to fade.

THIRD PLACES

According to author Jack Behrens, "Big bands, some music historians believe, were in trouble by the end of World War Two, less than a dozen years after the swing era officially began. Sadly, bands disappeared from coast to coast tours by late 1946. But ballrooms continued for another decade or so, struggling to find ways to draw crowds without the bands."[105]

The dawning of the rock-and-roll era provided new music and new audiences for the Elms. Cleveland radio DJ Alan Freed (who worked for a time at WKBN in Youngstown) helped popularize the term "rock and roll" and introduced mixed audiences in Ohio to many of the budding black rhythm and blues acts of the day. Clarence King quickly made the switch to the new sound, booking the biggest groups and singers in the nation. Bill Doggett, Bo Diddley, Ike and Tina Turner, the Drifters and Fats Domino

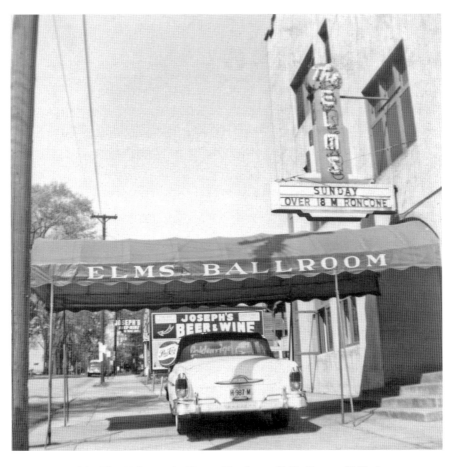

The exterior of the Elms Ballroom, looking up Elm Street, 1959. *Courtesy of Mike Roncone.*

all played the Elms. And Tony Cavalier booked the likes of the Champs, Frankie Avalon and Bobby Darin.

"Uncle Clarence was always busy, always on the go," Martel Davis Allen recalled. "We spent the night at my uncle's house once, and in the morning, we ate breakfast with Chubby Checker. But we were so young that we didn't know who he was."

Rayen High majorette Liz Moore attended many of the Clarence King shows at the Elms during the late 1950s and early 1960s. She remembered men wearing wide-legged trousers with long chains hanging down below their knees. The ladies showed up formally dressed with their Sunday shoes. "You went with your friends; some brought their girlfriends, and husbands and wives went, too," Moore said. "We danced the chicken, the dog, the fly and the jitterbug. Kids today do a lot of dances using their torsos, but ours were mostly from the waist down."

James Brown became one of the most popular acts Clarence King brought to the Elms. When Brown first played the Elms in the 1950s with his backing band the Famous Flames, they arrived late for the show. Profusely apologizing for their tardiness, Brown offered to return part of their pay. King refused. "He never forgot that. It paid off in later years," King later said.[106]

Brown and the Famous Flames played the Elms in the mid-1950s, and Brown returned in '57, '59, '60, '63 and '64. He went on to develop somewhat of a relationship with the area, later bringing two Youngstown musicians into his band. East High graduate Nate Jones joined the James Brown band in the late 1960s, and Frankie Halfacre, a local DJ, was hired as his record promoter. Brown returned to Youngstown in 1969 to play a benefit at South High School stadium. Seven thousand screaming fans packed in to hear Brown, who was presented with the key to the city. One young man in particular played special attention that day; like Nate Jones, he would later join Brown's band.

Jerry Poindexter grew up on the city's east side and played with Ronald and Robert "Kool" Bell before they moved to the East Coast and formed Kool and the Gang. Like Kool and his brother, Poindexter was bound for show business. "The first time I saw James Brown was at the Nu Elms Ballroom. I rode my bike down to see him; I remember he came in a white 1957 Cadillac," Poindexter said. "I knew then that I wanted to be a musician." Years later, after a chance meeting with Brown, he got his shot. After getting a rare opportunity to audition for Brown, Poindexter joined The J.B.'s (Brown's backing band) as a keyboardist in 1978, and he was Brown's personal assistant until the "Godfather of Soul" passed away in 2006.

THIRD PLACES

The Elms regularly featured the best national and local music acts. *Courtesy of Mike Roncone.*

While Clarence King brought in out-of-town acts to the Elms, the ballroom also featured the best musical talent in the Mahoning Valley in the 1950s and 1960s. Among those was Del Sinchak. The future Grammy nominee started playing polka music at a young age and formed his first band at twelve, eventually recording for Balkan Records out of Chicago. As rock-and-roll started to dominate the airwaves in the 1950s, Sinchak made the switch from polka to the new sound. "I remember local DJ Dick Biondi telling me, 'Why don't you learn a few rock songs? I'll hire you to play at the record hops, so we can move to a live band portion,'" Sinchak said. "He also told me, 'I hate to tell you, but the name Del Sinchak is not going to cut it in the rock era.'"

Taking Biondi's advice to heart, Sinchak took the stage name "Del Saint"; his backing band was dubbed "The Devils." The Youngstown Playhouse made a white turban for Sinchak to wear while the band wore blue suits. "Dick promoted our first gig at the Elms for weeks before it started," Sinchak remembered. "By the time the gig came, you couldn't get in the place." In 1957, Sinchak and his group went into the studio to back the Edsels on their single "Rama Lama Ding Dong," a doo-wop-era hit. They also accompanied Chuck Berry and Conway Twitty and continued to play the Elms regularly for several years.

Of all the local acts that played the ballroom during the rock era, few were as popular as Mike Roncone. The versatile Mike Roncone Orchestra regularly headlined shows at the Elms, the Idora Ballroom, the Ritz Bar

Elms manager James E. (Eddie) Campbell (right) and musician Mike Roncone pose in front of the ballroom in 1959. *Courtesy of Mike Roncone.*

and countless other top venues of the era. When Little Anthony and the Imperials played the Cathedral in New Castle, Pennsylvania, in 1964, they found Roncone's name, not theirs, at the top of the bill. He regularly drew big crowds at the Elms during the late 1950s and often played the New Year's Eve shows. "It would be nothing to get a thousand people or more in there," Roncone said.

Once during a particularly big show, Elm's manager Eddie Campbell asked Roncone if he would like to meet Jackie Wilson before he went on. "We went back to see him, and he had about twenty patent leather shoes—every color imaginable—in his travel bag on the wall," Roncone recalled. "I said, 'Jackie, what are you doing? You're only going to be wearing

one of those on stage.' And he said, 'Hey, you never know, man.' Maybe he could have changed shoes once during intermission, but he brought that thing wherever he went."

Local WHOT DJ Johnny Kay dubbed the early rock era the "Fabulous '50s." "The record companies began to boom…kids loved sock hops," Kay said. DJs could make more money doing hops than they could from their salaries alone, according to Kay.[107] Charismatic jocks earned loyal followings, especially at the Idora Ballroom and the Elms. One of the first to do so was Dick "The Wild I-tralian" [*sic*] Biondi.

The future Radio Hall of Fame inductee landed in Youngstown in 1954, just as rock-and-roll began to penetrate the national consciousness. One of the very first DJs at WHOT-AM, Biondi became a main attraction at the Elms. Biondi later said "Youngstown was very special to me because that's where I was 'baptized' into music. I helped put the tiles down on the station floor in Youngstown…We used to bring in artists to our record hops; I was the first one to bring them into that town. We had people like Paul Anka, Fabian, Frankie Avalon, and others."[108]

Known for climbing up the flagpole at Idora Park and broadcasting for nearly two days straight, Biondi began antics in Youngstown that mirrored those of the rest of his career. "Dick did crazy stuff all the time, but the kids loved him," Del Sinchak said. "He'd paint his beard school colors for different events at the Elms. For Ursuline, he'd have one side of his beard dyed gold and the other side dyed green."

Musician Robert Bigelow frequently played the Elms in the 1950s with his band Buzz Dull and the Jumpin' Jupiters. Years later, he ran into Biondi during a gig in Chicago. "He had become famous," Bigelow said. "But he said if had to do it all over again, if he could pick one spot, he said he'd rather be back at the Elms Ballroom and Idora with his kids."

After Biondi's departure, the enormously popular hops at the Elms eventually came to be hosted by DJ Johnny Kay on Sunday afternoons and on Friday nights by the irrepressible Boots Bell. Youngstown's most popular DJ was born Ralph Ross Bellito in 1933. Bell served in the Korean War, losing most of a finger and suffering a bayonet wound to his knee, which led to his using a cane in later years. After returning from the war, Bell attended broadcasting school and went to work on air for WBUZ in Fredonia, New York.

Bell came to WHOT in Youngstown in 1959. Like Dick Biondi, he attracted a large following at the Elms and during the summers at the Idora Ballroom. The bearded Bell became the perennial favorite at the Elms

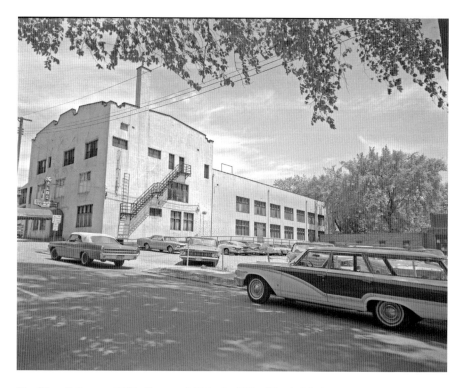

The Elms Ballroom, 1965. *Courtesy of Mahoning Valley Historical Society.*

Ballroom, and everyone knew him by his trademark slogan: "Yes, indeedy, doody-daddy! Have yourself a happy!"

Betty Peters Soni frequented the hops hosted by Bell during the early 1960s, and she appeared on his dance show. "Boots had a local show on television on Fridays before the dances at the Elms; it was called *Dance Party*," Sonni said. "Kids would come to the studio, and they would film it, just like [*American*] *Bandstand*."

According to Don Hanni III, who danced at the Elms frequently, "There was a certain crew of people who were on that show because they went to the Elms and had gotten to know Boots Bell." *Dance Party* appeared on Channel 33 locally, and it bore a resemblance to *45 Hop*, another local dance show hosted by Al Dejulio on WXTV.

While many ballrooms faded away during the early 1960s, Boots Bell and a plethora of local bands and national groups continued to pack the Elms every season. One of the most popular local bands during that era at the Elms was the Del Rays. The members of the Del Rays hailed from both Struthers and Campbell, Ohio. Only two members—Danny Carbon,

the keyboardist, and drummer Bruce Dill—had experience playing shows. Nevertheless, for a short period of time, they became the most popular regular act at the Elms and in the city.

The Del Rays had trouble getting started, as no local venues knew them, nor would they take a gamble and book them. The group played for a time under the name "Brucie and the Flames" at the Silver Dollar club on East Federal Street, honing their routine. They began by learning Isley Brothers songs on the jukebox like "You Better Come Home," "I Say Love" and "Nobody but Me," which they played together in a medley.

Eventually, the group decided to approach management at the Elms. "Danny and I went down to the Elms and said you've got to hire us," drummer Bruce Dill recalled. "But they said they didn't know us." The group finally got their chance after the ballroom lost an act at the last minute on a busy weekend. "We went from being unknown to an instant success," Dill said.

On a typical Friday night, the Del Rays could play for two thousand people at the Elms, and they brought their popular Isley Brother's medley to the ballroom. "The medley at the Elms lasted about fifteen minutes," Dill remembered. "When everyone was done, they were soaking wet. And there were some good dancers at the Elms; they'd make up their own dances to the medley." The group became so popular that Boots Bell dubbed them the "Fabulous Del Rays," a name that stuck.

Like other groups, when the Del Rays played, they shared time with whomever the DJ was that night. "The disc jockeys just started out playing records, but the musicians union and the AFL/CIO got involved and said that you just couldn't just play records," Mike Roncone remembered. "So at every record hop at the Elms or Idora you had to have a five-piece band. They would alternate between playing records and the live band playing."

Probably the most popular band to play the Elms in the mid-1960s went on to become one of the most famous Ohio bands of the era. The Human Beingz started out as the Premiers in 1964. The group's original sound and look were more reminiscent of the late 1950s or early 1960s, as was its original name.

"Music was beginning to change from the early 1960s," vocalist and guitarist Joe "Ting" Markulin remembered. Music like "Runaround Sue" was starting to morph into a different sound. Sensing this, the group changed their style and name to the Human Beingz (later mistakenly changed to "The Human Beinz" by Capitol Records).

Markulin remembered going to see the Del Rays at the Elms before joining the Human Beingz. "The Del Rays were *the* band," Markulin said.

LOST YOUNGSTOWN

The Elms Ballroom was torn down to make way for the university student center (now greatly expanded) in late 1965. *Photo by the author.*

After the Del Rays disbanded, the Human Beingz filled the void. At the height of its popularity, the group often played nine times a week, including afternoons and evenings. "We thought we were on top of the world if we were playing the Elms, because that was basically the place," Markulin recalled. But while the Human Beingz went on to sign a national recording contract in 1967, the Elms faced a much bleaker fate.

The age of urban renewal began locally in the late 1950s. In 1961, an urban renewal plan for the area around the Youngstown University neighborhood was proposed. Designed to clear residential and business areas for future university expansion, the program's plan encompassed around a hundred acres—including Elm Street. Nearly sixty longtime north side landmarks faced the bulldozers. The old Fordyce mansion, the North Side Shriver-Allison Funeral Home and the Elms Ballroom were all doomed. In September 1965, the city demolished the Elms, a ballroom that "probably entertained more people than any other institution of its kind in this area."[109]

Clarence King moved his dances to the Idora Ballroom until his retirement in 1968. Fittingly enough, James Brown was the headliner for his last show. Reed's Arena on Oak Hill Avenue became the prime venue for the best R&B acts coming through town, and Tony Cavalier continued to operate the

Idora Ballroom, although he still dreamed of reviving the Elms at another location. But the old Elms itself disappeared into history. It is hard to tell today where the ballroom once stood; it is difficult to even imagine that a neighborhood once pulsed in what is now the heart of Youngstown State University. However, despite it all, the memory of the Elms and its place in musical history remain.

6
THE NEWPORT THEATER

For many years, the glowing marquee of the Newport Theater marked the journey down Market Street from Youngstown into Boardman Township. Long crowds could be seen in the evenings waiting outside the sumptuous Art Deco building. Every Saturday morning, children skipped through the theater's lobby into line for concessions, anxious for the kiddy matinee to begin.

Sometimes thought to be within the Youngstown city limits, the Newport actually stood just over the line in Boardman. It represented the beginning of the suburban movie houses locally, but it also functioned as perhaps the classiest of the neighborhood theaters in the area. When the Newport was demolished, the Youngstown area lost a fabled movie house and one of the last Art Deco buildings in the Mahoning Valley. Yet even as the years pass, the memory of the Newport remains strong for current and former residents in both Youngstown and Boardman—many of whom considered it "my theater."

In the summer of 1941, Youngstown area residents got word that another movie house would be opening. Owner Paul Raful promised it would be "the nicest theater in the Youngstown vicinity."[110] Months later, as the news of Pearl Harbor shook the nation and the area, the new theater neared completion on Midlothian Boulevard in between Market and Hillman Streets.

It seemed an inauspicious time for a new theater. Able-bodied men were heading for battlefronts in Europe and the Pacific. Rationing of all kinds impacted consumers, and the production of new automobiles ceased as the car companies retooled to manufacture for the military. However, the appeal of the movies did not wane, as people sought an escape from the reality of wartime.

THIRD PLACES

In this atmosphere, the Newport Theater opened at the beginning of 1942. A channel letter sign done in gold neon topped the elegant Art Deco building and another neon sign decorated the eastern side of the theater. The exterior consisted of a reddish brown terra cotta with a light-colored buff terra-cotta framing the foyer windows, which stood above a garden area surrounded by rail. The theater's tall, fluted windows allowed a glimpse of the plush foyer inside. Theater patrons walked through three separate elements of the building before getting to their seats—the lobby, the foyer and the standee space, where guests waited for ushers to seat them.

The foyer was perhaps the most striking element of the theater's interior. Thirty-foot-high windows with velour drapes illuminated the room, which contained settees, lounge chairs and smoking stands. Beyond the foyer lay the standee space. The nearby ladies' restroom featured an attached powder room.

The main auditorium could seat 975 people, making it larger than the next two biggest neighborhood theaters in Youngstown—the Uptown and the Foster. It featured six murals (sixteen feet high by eight feet wide) representing half of the signs of the Zodiac. Done by local artists, they were visible in the dark only under the theater's Conti-Glo black lights. Burgundy velour covered the seats and the sidewalls. The theater's floor sloped downward, and seating was designed so the heads of individuals in front of them never obstructed a patron's view. The Newport also offered hearing-aid outlets. Patrons could pick up the specially designed aid at the box office, which could be plugged in when seating in a row of specifically designed seats connected to jacks in the wall. The Newport, unlike other theaters in town, also had some double seats at the ends of the rows with no armrests in between. Perfect for couples and dates, they proved to be very popular.

The new theater was billed as "the most beautiful neighborhood theater in northeastern Ohio," and enormous crowds came out on opening night for a double feature of *Adventure in Washington* and *International Squadron* starring Ronald Reagan. From the beginning, the Newport Theater sought to be a community-oriented enterprise. Opening night's admission was free; patrons were expected to instead donate to Red Cross officials at the box office. WFMJ conducted a live broadcast of the event for those who couldn't make the sold-out shows. The immaculate building and the successful opening also raised the local reputation of the Newport's owners.

Paul and Joseph Raful enjoyed long careers in the theater business, and the Newport Theater represented their crowning achievement. For many years, Paul Raful ran movie houses in Birmingham, Alabama; Akron; Pittsburgh; and Albany, New York. He also operated the Ohio Theater near the Uptown

LOST YOUNGSTOWN

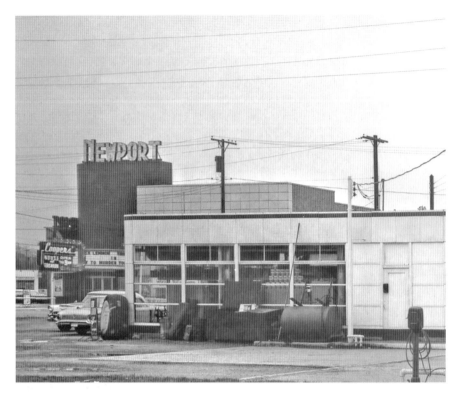

The Newport Theater was the first local theater built in a township. *Courtesy of Mahoning Valley Historical Society.*

district until the widening of Market Street led to its closing. Joseph ran a theater in Newton Falls, Ohio. When eyeing locations for the future Newport, the brothers picked the far northern edge of once largely rural Boardman. "You can't deny so large a residential area the convenience of the more urban areas," said Paul Raful in 1941. "The people of Boardman Township and the southerly end of the city would enjoy having another theater in which to find relaxation and entertainment."[111]

While the Newport clearly catered to crowds from both Boardman and the south side of Youngstown, its construction was seen as one more move farther away from the city center and into the then sparsely populated suburbs. Twelve thousand people called Boardman home in 1940, and the township only received its first rural post office in 1941. However, the area around the Newport had already begun to grow.

The exclusive neighborhood of Forest Glen was within walking distance of the theater. In 1945, the original Handel's Frozen Custard opened nearby on

the corner of Market and Midlothian in a Sohio station. "It was a gas station very close to the Newport," Boardman resident Fred Posey remembered. "On one side of the station, they started doing a business selling frozen custard. You walked up, and there was a little window with a girl behind it, and you got a cone." In 1948, the far south side of the city near the Newport almost played host to a mall complex called the "Mar-Hill Markets" before a zoning reversal ended the project. By the early 1950s, however, Boardman was beginning to grow in earnest.

In 1944, Peter Wellman, perhaps the best-known theater owner in the area, acquired the Newport from the Raful brothers. The Newport reached its zenith under Wellman, an immigrant with a keen eye for real estate and a vast knowledge of the theater business. Wellman arrived at Ellis Island by himself at age fourteen. An uncle in Pennsylvania promised to take the young boy in, and by the age of twenty-one, he had already bought his first theater in Blairsville, Pennsylvania.

In 1934, Wellman purchased the Mock Theater in Girard, which he renamed the Wellman. He built the New Mock Theater on the same block in 1937. During the 1940s, he added the Uptown and the Mahoning, the Home Theater (located on McGuffey Road in Youngstown), the Victory Theater on West Federal (later known as the Fox), the Palace Theater in Hubbard and the Campbell Palace Theater, the latter of which he leased out. Wellman later controlled all of the Youngstown area drive-ins, except for the Sky-Hi Drive-In.

Wellman had a fastidious way about him and paid close personal attention to all of his theaters. "Pete Wellman tore tickets himself all the time," former Wellman employee Bob Vargo said. "He loved to meet the people coming in." Wellman was the type of hands-on owner who would hide popcorn under a smoking stand and then come back the next day to see if the cleaning crew had actually moved the stand and discovered it. Very little happened in his theaters that he was not personally aware of.

As the theater's success grew, he opened what could be considered the Newport's sister theater on Belmont Avenue in Youngstown in 1948. Three thousand people attended the opening festivities, including Mayor Charles Henderson, who congratulated Wellman on opening a movie house on the city's north side. The Belmont Theater cemented Wellman's reputation even further, and the pond with a lighted fountain outside became a prominent landmark on the busy Belmont commercial corridor.

The Belmont Theater, like the Newport, was a neighborhood theater. Theaters traditionally started in core downtown areas, except for some small nickelodeons. The large downtown movie houses like the Palace,

LOST YOUNGSTOWN

Warner, Paramount and State dominated the city for years. But before the explosion of television in the 1950s, the demand for closer venues to serve growing neighborhoods in Youngstown led to the construction of a variety of community theaters. The Belmont Theater and the Newport became among the most popular theaters outside downtown, and the Newport was the only one located in a surrounding township.

By the 1940s, a shortage of parking downtown was causing enormous problems for retail stores and theaters in the commercial corridor. The city worked out an arrangement with the Newport and the Belmont where both theaters would allow city busses to pick up people who would leave their cars in the theaters' parking lots and head downtown to shop. Both theaters enjoyed an advantage over those downtown, with the Newport's lot capable of holding 250 cars and the Belmont's capable of handling 400. Intense competition from the downtown movie houses, however, led to the closing of the Belmont and its conversion into an Atlantic Mills discount store in 1958—leaving the Newport as the top second-run neighborhood house.

The Newport continued to act as a good neighborhood to the surrounding communities, and during much of the 1950s, management sought to enforce what it considered good etiquette and morals. In 1953, the Newport

The former Belmont Theater building, now owned by Humility of Mary Health Partners, was once a crown jewel of the Wellman chain, along with the Newport Theater. *Photo by the author.*

partnered with the Protestant Motion Picture Council to bring in what were considered educational films aimed at youths and families. Pictures like *When I Grow Up*, starring famed child actor Bobby Driscoll and Robert Preston, and *Room for One More*, starring Cary Grant and Betsy Drake, were featured. In 1958, the Men's Apparel Club of Ohio praised the Newport after management banned admission to women wearing slacks and anyone wearing blue jeans.[112] Even the downtown theaters, where formal dress was almost always expected, refused to take such a step.

Kid-friendly matinees predominated every weekend at the Newport. "Every Saturday, every kid from the far south side and North Boardman wanted to be there," according to former patron Bill DeCicco. "You would have kids lined up from the ticket window all the way down and around Hillman Way." The matinees were typically around nine cents and featured attractions like Jungle Jim films, Three Stooges comedies and Looney Tunes cartoons. Door prizes were often given out in between the features.

Besides sponsoring what it considered to be family-friendly fare, the theater also sought to aid local charities and organizations. When nearby Good Hope Lutheran Church's congregation grew too large for its facilities in 1950, it found itself without a worshiping space while a new building was being built. The Newport opened its doors to the church, hosting services and Sunday school in the theater for fifteen months.

During the 1950s, Peter Wellman divested himself of the Newport and his theaters in Girard, perhaps as a prelude to retirement. However, he apparently thought better of the move, reacquiring the Newport and the Wellman at the end of the decade. For years, the Newport primarily served as a second-run theater, albeit a very successful one. Wellman aimed to change that.

"We got *South Pacific* and did even better with it than the State Theater had," Bob Vargo remembered. After he reacquired the Newport, Wellman began outbidding the downtown theaters for films like *Lawrence of Arabia* and *The Guns of Navarone*. From that point on, the Newport showed a variety of wildly successful first-run films, such as *Rosemary's Baby*, *The Odd Couple* and *What a Way to Go!* with Shirley MacLaine.

Until the mid-1960s, the theater still bore many of the touches of an old movie house. Ushers wore a bellhop-style uniform (dubbed a "monkey suit" by the staff). As the decade wore on, those uniforms gave way to double-breasted suits and ties. In a more modern touch, the theater contained a milkshake machine, which used a formula, probably the only such product offered in area theaters.

All of the theater's artwork and the marquee were done by hand. "They had an artist come in, and he would do all the artwork and posters," former

employee Jeff Pillot explained. "He would hand paint a big mural, and we would have to go out on ladders and put these large masonite sheets up around the marquee. I used to go upstairs and watch him paint; it was real art."

Some of the theater's most successful films during those years were *The Longest Day*, *It's a Mad, Mad, Mad, Mad World* and *Thunderball*, which became an enormous hit after the Newport landed the film instead of the State Theater downtown. James Bond films subsequently became big draws at the Newport for years.

A succession of companies operated the theater from the 1960s into the 1970s. Peter Wellman gradually sold off most of his properties, and by the time of his death in 1969, only the Wedgewood Theater in the suburb of Austintown remained under his control. The ill-fated Broumas Theater group ran the Newport for a time before going bankrupt. By the end of the decade, Cooperative Theaters of Cleveland and Youngstown Enterprises Inc., which managed the Newport on their behalf, soon were confronted with a changing business landscape as the 1970s dawned.

By the early 1970s, nearly all the old downtown movie houses were gone, with the exception of the Paramount Theater, which closed at the end of 1975. Even neighborhood theaters outside downtown faced hard times. The Foster Theater, located on the city's south side, became an art house and then an adult theater. The Uptown Theater gradually weakened as the decade ended. Most of the other neighborhood theaters—and the movie houses in the nearby industrial cities of Struthers, Girard and Campbell—closed. New suburban multiplexes in the suburbs of Youngstown quickly challenged the Newport.

The Newport showed a mix of first-run films during the 1970s, such as *Macon County Line*, and cult films like *The Legend of Boggy Creek*, *Zardoz* and *Embryo* with Rock Hudson. Raucous showings of *The Rocky Horror Picture Show* became a theater staple later in the decade. The opening of *The Exorcist* in March 1974 proved to be one of the biggest spectacles of the decade in the local theater world.

"I remember riding past the Newport and seeing this long, long, line," James Moore recalled. "Ambulances were parked outside in case anyone had a panic attack or something. I never saw a line like that at the Newport." A huge success for the theater, *The Exorcist* ran to sellout crowds for two months.

Yet the slow deterioration of the south side of Youngstown began to affect the Newport's business by the early 1980s. Kelly Bancroft attended the theater during the early part of that decade: "Back in the '60s, you could get a light for your Christmas tree that had five or six different colors that

THIRD PLACES

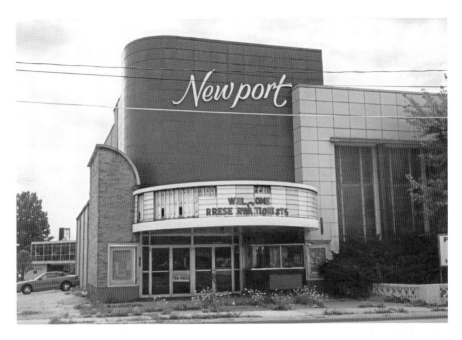

The abandoned Newport Theater as it appeared in 1996, almost a decade after it closed. *Photo by Steve Felder.*

flashed in order like a disk. They had lights like that on the dark red screen curtain, which came up from the floorboards. It seemed very soothing to me to watch while waiting for the movie to start." But despite the theater's old-time charm, business was not what it used to be. "I remember there were never many people," Bancroft said.

In 1987, after several years of showing second-run features, management announced that the Newport would become a "dollar theater." According to local historian Richard Scarsella, "The problem with that theater was that they could no longer get the top production films. There was pressure from the distributors to book movies into twin cinemas. The cost to put a wall down the center of and retrofit the theater with surround sound was cost prohibitive."

Youngstown Enterprises announced the closing of the Newport Theater in 1988; a one-screen theater showing dollar films could no longer compete with larger cinemas in the continually sprawling suburbs. Yet despite being forty-six years old, the Newport still maintained the largest screen of all the local theaters. *Fatal Attraction* ran as the last feature film shown, and after decades of entertaining the Mahoning Valley, the Newport's doors closed in the spring

Six years after the Newport's demise, the nearby Forest Glen Homeowners Association began working toward getting the neighborhood on the National

LOST YOUNGSTOWN

A Burger King stands today on the site of the old Newport Theater. *Photo by the author.*

Register of Historic Places. Some hoped that initiative might lead to the rehabilitation of the old Newport.[113] At the same time, a local Burger King across from the Newport eyed the old theater's parcel as a potential spot to relocate—a move designed to head off McDonald's, which also looked to acquire the Newport property for a new store. After a prolonged back-and-forth fight to obtain the property, Burger King purchased the Newport after Youngstown annexed the site into the city. Local residents opposed the move, as did Easy Street Productions, which advocated for the Newport to be leased or sold to a local theatrical company. Despite those pleas, the Newport was bulldozed, and a Burger King now sits where the glamorous Art Deco showcase once thrived.

The Newport is only a product of the past now. But the theater's fate is an instructive lesson. For the two neighborhood theaters left on the south side, the Foster and the Uptown, the future is still uncertain. It remains to be seen whether local groups will form to attempt to save them from a future wrecking ball. As for the Newport, it will live on for a long time in the collective memory of those who discovered their love of movies inside its darkened auditorium.

PART III
COMMUNITIES OF THE PAST

7
FROM MONKEY'S NEST TO BRIER HILL

A TRIP DOWN OLD WEST FEDERAL

Today, West Federal Street runs from Youngstown's Central Square past the Spring Common Bridge, where it eventually becomes Martin Luther King Jr. Boulevard. Light industry, grassy lots and a new public housing development mark the journey from there to Brier Hill. It is finally punctuated by the Vallourec Star steel mill, which straddles Youngstown and the city of Girard. At one time, West Federal Street extended far beyond Spring Common into the heart of an archipelago of immigrant communities and industrial concerns.

In those days, an area known as Westlake Crossing lay beyond Spring Common Bridge. In the later nineteenth century, "the crossings," as locals referred to it, was marked by a rather dangerous intersection where the Erie Railroad passed through. The area was eventually renamed in honor of Covington Westlake, a powerful Mahoning County Auditor, in the early twentieth century.

Thousands of immigrants arrived in Youngstown to settle in neighborhoods around and beyond the crossings in the nineteenth and twentieth centuries. Poles, Ukrainians, Slovaks, Germans, Italians, Croatians, Mexicans, Irish, Welsh, Hungarians, Serbians and African American migrants from the South arrived in neighborhoods like Monkey's Nest and Brier Hill. These were some of the very earliest dense settlements in Youngstown; many of these newcomers went to work in the local mines, iron furnaces and, later, the mills of Youngstown Sheet and Tube and the U.S. Steel Ohio Works.

LOST YOUNGSTOWN

One of the last signs of old West Federal is revealed in jumbled letters on a long-shuttered building. *Photo by the author.*

One of the first settlements in the area sprang up near a wide bend in the Mahoning River beyond Spring Common Bridge in the early nineteenth century. One of the major landholders in that area, John Caldwell, helped build the Civil War monument on Central Square, which replaced a lily pond. The Caldwell District, as it became known, developed from a farming community to an area housing a variety of immigrant groups who came to work the early iron furnaces. The Welsh settled in Caldwell and in Brier Hill, drawn first by the coal mines, followed by the Eagle Furnace and the Cartwright and McCurdy Mill, the latter of which was built on Moore Street (present-day West Rayen Avenue).

The character of the community turned increasingly industrial as the century continued, and peach orchards gave way to densely packed housing. The first school in the area opened on Caldwell Street in 1886, and the local Hungarian community built the first church in the neighborhood soon afterward.

Around the 1880s, Southern Europeans and Eastern Europeans, especially Slovaks and Croatians, began settling in Caldwell. The Croatian and Slovak peoples in particular had a huge impact on the area. Croatian workers provided much of the labor to build the area's infrastructure, and Croatians paved most of what became West Federal Street. But for years, they had

COMMUNITIES OF THE PAST

no church in the area; most attended the Slovak church Saints Cyril and Methodius, located on distant Wood Street.

In 1910, the Croatian Association of Youngstown brought together the funds to buy frontage on Covington Street to build Saints Peter and Paul Church and an adjoining parish house. Many if not most of the initial worshippers came from Caldwell. Two years later, the Croatian Educational Club incorporated, and it quickly sought to build a meetinghouse for all Croatians in Youngstown. In 1916, the Croatian Home opened on West Federal, not far from Marble Street in what was quickly being called "Monkey's Nest." The sounds of the Croatian Singing Society or "Strossmayer" and the tamburica (a mandolin-like instrument) became commonplace in the neighborhoods around the Croatian home. Croatian businesses like the Zagreb Café also sprang up on Covington Street near Saints Peter and Paul Church.

The Croatian presence continued in the Caldwell neighborhood (then known as Monkey's Nest) well into the 1950s. A local man known as the "Croatian Czar" served as a banker for immigrants unaccustomed or unable to deal with English financial institutions. Some of these newcomers quickly

Caldwell Street in Monkey's Nest, circa the late 1950s. *Courtesy of Mahoning Valley Historical Society.*

LOST YOUNGSTOWN

Caldwell Street was shortened and mostly deactivated after urban renewal and the construction of I-680 during the 1960s. *Photo by the author.*

established small businesses of various kinds. "My father had the Pacic Café, which he later changed to Caldwell Café; it was down on Caldwell Street," Edo Pacic recalled. "There were two corner grocery stores near us, and a beer garden down on Manning Avenue. We were all Croatian."

Youngstown's early neighborhoods became well known for their imaginative names: Boot Hill, Brier Hill, the Blocks, Soup Hill, Scienceville and Smoky Hollow. At the beginning of the twentieth century, the moniker "Monkey's Nest" joined them, replacing Caldwell and "Lower Brier Hill" as the common name for the district around the river bend. Some contemporary accounts regard the name as a pejorative term for the neighborhood's later African American majority population. The term, however, dates back long before that to at least 1916, when the *Youngstown Vindicator* referred to it as the nickname for a local saloon.[114]

A variety of theories abound regarding the origins of the name Monkey's Nest. One story posits that a large group of monkeys escaped from a circus train at Westlake Crossing, scattering throughout the Caldwell area. Another version claims that Monkey's Nest evolved from the pejorative name "Hunkie's Nest," used to describe the then large population of Hungarians and Slavic peoples in the district.

COMMUNITIES OF THE PAST

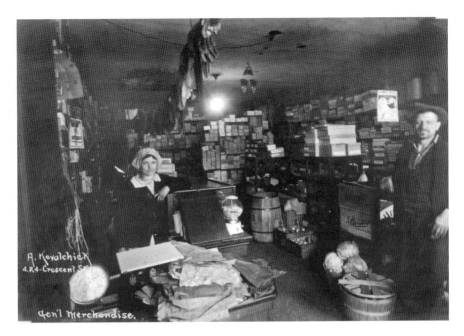

The Kovalchik general store, located at the corner of Bridge and Crescent Streets, circa the early 1900s. *Courtesy of Ken Kovalchik.*

According to a history written by Professor Milan Richard Karas in 1935, the name came from a local saloon on Bridge Street, which featured live monkeys in the window; the owners thought it would attract customers and serve as a local landmark.[115] "It was located at the corner of Bridge and Crescent Street," according to Bill Kovalchik. "And the way the whole area got its name was because of that bar. My grandparents had a grocery store that was located right next to the Monkey's Nest beer garden."

Monkey's Nest encompassed about two and a half square miles. West Federal Street bound it to the north, the Mahoning River to the south, the end of Marble Street to the east, and West Rayen Avenue to the west not far from the West Avenue Bridge. By time of the Depression, both Westlake Crossing and Monkey's Nest had established a fearsome reputation. Jack Warner of the famous Warner brothers wrote in his biography of having run with a gang in Westlake Crossing during his youth, and in 1933, a professor from Ohio State University researching midwestern gangs pronounced Monkey's Nest and Campbell as the toughest places he had surveyed.[116] But many recollections of the time paint a different picture.

Joseph Sharo later wrote of his own experiences in Monkey's Nest during the Depression: "What did Monkey's Nest offer to a six-year old that other

places did not—everything, including smoke, graphite, sulfur and, especially, dirt. In spite of these factors, the people who lived in this environment were meticulously clean. Their personal pride was devoted to the cleanliness of their home."[117]

Reflecting on conditions in and around Westlake Crossing and Monkey's Nest, the city's Children's Service Bureau and several other agencies helped form the Caldwell/Nelson Settlement House. Other settlement houses soon spread to neighborhoods in Haselton on the east side and on Franklin Avenue on the south side. The Caldwell Settlement provided daycare services, hot lunches for children and Americanization classes for immigrant adults. They also hosted "fresh air trips," where children had opportunities to travel to the country to experience wildlife and get away from the ever-present smoke of the nearby mills.

In 1929, the James Butler School first opened in the neighborhood on West Rayen Avenue, serving elementary students who previously had to walk several miles to classes. Even the nearby Carnegie Steel Company donated funds to build Union Works Playground, which became "one of

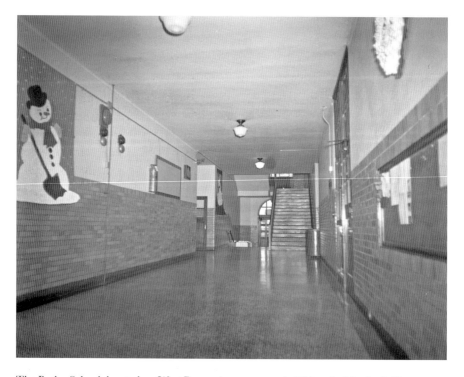

The Butler School, located on West Rayen Avenue, served children in Monkey's Nest. *Courtesy of Mahoning Valley Historical Society.*

COMMUNITIES OF THE PAST

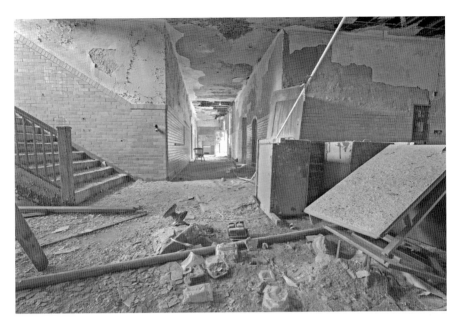

The vacant Butler School was the last remnant of Monkey's Nest left when it was demolished in 2013. *Photo by the author.*

the best playgrounds" in a city that lacked real recreational opportunities for children, according to Professor Karas.[118]

During the 1940s, former Monkey's Nest resident Helen Tatarka attended community programs at the Caldwell/Nelson Settlement regularly. "Every Saturday the whole family would go down to the [settlement] house, and different ethnic groups would showcase their food, music, and dances. Everyone brought different ethnic dishes. I'll never forget the Mexican Hat Dance, which all of the Mexican families used to perform."

The first Mexicans began arriving in Youngstown after southern and Eastern European immigration to the area had crested. There were 236 Spanish-speaking families in Youngstown in 1930—a number that grew larger after the arrival of Puerto Rican immigrants during the 1940s. The local families were known for their carefully tended and manicured gardens. Some families moved to Brier Hill; others settled near the Mahoning River in Monkey's Nest. Probably the first Mexican restaurant in the city operated near Bridge Street in Monkey's Nest.

African Americans also began arriving in larger numbers after World War I as part of the first Great Migration out of the South, settling on the east side, the lower part of the south side and near Westlake Crossing.

LOST YOUNGSTOWN

Vernacular housing characterized much of the dwellings in Monkey's Nest. *Courtesy of Mahoning Valley Historical Society.*

Working-class families lived mostly in Monkey's Nest, and many of the men—like their European counterparts before them—found jobs at the Ohio Works.

Several notable African Americans emerged from the area. Municipal court judge Lloyd Haynes and Harlem Globetrotter George Stevenson were born in the neighborhood. Mary Lovett Belton broke boundaries as the first black elementary school teacher at the Butler School. Reverend Lonnie Simon, who later marched with Dr. Martin Luther King Jr., began his long tenure at New Bethel Baptist Church, which was then located in Monkey's Nest.

A small African American commercial corridor sprang up on the opposite side of West Federal Street around Covington Street and North Avenue during the 1940s and 1950s. Buckeye Elks, Soso's club and the Whale Inn were all prominent watering holes. The West Side Social Club on West Federal Street attracted performers like Count Basie, who visited when in town. Many of those performers stayed in black-owned hotels such as the Hotel Allison on North West Avenue. Two of the most

COMMUNITIES OF THE PAST

The Intersection of Bridge and Crescent Streets in Monkey's Nest, 1961. *Courtesy of Mahoning Valley Historical Society.*

notable black clubs in the city, the Cotton Club and the Black and Tan Club, entertained the locals.

Hotel owner William "Uncle Billy" Rideout started the Cotton Club at its original location on East Federal Street. It relocated to West Rayen Avenue in Monkey's Nest during the 1940s. "The night life was when blacks and white got together," Isadore Blakeny later said of the time. "We had several top black clubs when I was in college. I managed the finest club in town called the Cotton Club."[119]

According to Blakeny, "All the musicians would come down there…The saxophones and trumpets would have jam sessions and play all night long." It was commonplace for musicians from white venues to come to the Cotton Club after hours, where one could find artists like the Ink Spots, Tony Bennett and Ella Fitzgerald among the crowd. Ella Fitzgerald appeared numerous times in Youngstown at the Club Merry-Go-Round on Salt Springs Road and at the Nu Elms Ballroom on Elm Street. While on tour with Dizzy Gillespie, Fitzgerald became romantically involved with bass player Ray Brown, a prominent musician from Pittsburgh. The couple took their wedding vows in late 1947 in Youngstown. She listed her address on the marriage license as 608 North Avenue near the heart of the black business district.[120]

LOST YOUNGSTOWN

The Black and Tan, located on West Rayen Avenue, usurped the fading Cotton Club as one of the top black clubs in the 1950s. "It [the Black and Tan] was the greatest spot in the world," according to former patron Harry Meshel. "They had jazz all the time; all the best jazz musicians were there. The best part about it was that these cats dressed beautifully. They spent money, and they worked. But I don't care where they worked: a guy might have been a janitor someplace, yet they all came out to the club in beautifully starched shirts with long collars. They were workers, and they were proud."

The growing African American population in Youngstown traditionally found itself cut off from many establishments in the city, including the YMCA. As a result, the West Federal Street YMCA opened for the use of Youngstown's black residents in 1931. Dr. Simeon Booker, who successfully helped open a Y for black residents in Baltimore, spearheaded the creation of the new facility. Governor George White spoke at the opening of the nearly $200,000 facility, built near the corner of West Federal Street and Madison Avenue. Despite the fact that segregation drove the need for a Y, the facility

The West Federal Street YMCA, between 1931 and 1940. *Courtesy of Kautz Family Archive, University of Minnesota.*

COMMUNITIES OF THE PAST

soon became a central place for the recreational and even educational needs of the black community.

"After the completion of the West Federal Street branch Y, you had club groups," said James Lottier, former physical director at the Y. "You would plan programs for clubs, and speakers came in. They tried to teach you in a manner to give you some incentive to try and make something out of your life. You had devotions of all kinds. There were organized choirs, glee clubs, craft groups, and dramatic clubs…You had something to participate in, other than just gym or swim classes there."[121]

Despite the construction of community facilities like the Y, constant overcrowding and inadequate housing plagued most of the neighborhoods around West Federal Street—and throughout the city itself. The problems of slums and inadequate sanitary conditions, which increasingly followed, caught the attention of the local, state and federal governments as the Depression deepened.

As the 1930s wore on, Youngstown faced a "housing shortage of unprecedented proportions," according to local officials.[122] Private developers proved unable to fill the need for safe and affordable housing, especially in industrial cities like Youngstown, which faced chronic housing shortages. In 1937, the Wagner-Steagall Act was passed. Also known as the United States Housing Act of 1937, the act provided, for the very first time in the country's history, federal subsidization of public housing on a large scale.

That same year, the newly created United States Housing Authority began to provide local governments with low-interest-rate loans for the construction of public housing. In early 1938, the very first slum demolition and public housing campaign conducted in concert with the Wagner-Steagall Act commenced near the West Federal Street YMCA. In the fall of 1939, Eleanor Roosevelt arrived for a tour of the new units. The First Lady showed great interest in the project, emphasizing that housing represented the heart of any community. "What I have heard and seen here this afternoon speaks well for the future," she said.[123]

Congressman Michael Kirwan also proudly touted the historic nature of the undertaking: "The Youngstown project was not only the first in the country to be authorized, but I believe it will be the first to be completed. It serves as a model for other cities."[124] The new project, dubbed Westlake Terrace, soon attracted applicants from all over the region. Nadine Parker's family moved to Westlake Terrace when she was a young girl. "It was like heaven. We had a bathtub and a toilet upstairs. Where we moved from, we

had to boil water and take it down [to] the cellar to the bathtub…It was a blessing to so many people."

The first families who arrived at Westlake in 1940 found spacious, well-built units. There were a total of 618 units capable of holding 2,500 families. Rents ranged between nineteen and twenty-two dollars a month, which was actually cheaper than rent in many of the nearby substandard dwellings. Units ranged in size from three to five and half rooms. The Lexington Settlement House (later renamed Hagstrom House) served as a center for recreational and community-oriented programming. A library, a gym, a miniature theater, a clinic for children and recreation rooms were all on the premises.

Despite the trying conditions of the time, a sense of community pervaded Westlake Terrace. "The neighborhood kids used to come around, and someone was always hungry," Nadine Parker recalled. "Mother never ran nobody away. She sat there and let them eat. When they were done you washed their plate and gave it to someone else. Mother always cooked enough for everyone."

Strict rules regarding income and eligibility pervaded at Westlake. A table regarding the maximum weekly and yearly incomes for eligibility was printed on all housing applications. Only families could apply, provided the parents were married. In the first decade of the project's existence, yearly incomes averaged around $800, and about half of those wage earners worked, if only sporadically or part time, in the local steel industry.[125]

Life was not altogether idyllic in Westlake, however. The project remained racially segregated into the 1950s. In 1948, after six years of delays and many urgings from the NAACP, the John Chase Pool opened near Westlake on Otis Street. The recreation center and $150,000 pool provided service to African American children who were denied entry to the North Side Pool. It became the city's seventh public swimming pool at the time, the others being Borts, North Side, Shady Run, South Side, East and Lincoln Park. Chase remained opened until 1985.

Beyond Westlake Terrace, West Federal Street passed through Brier Hill. One of the most fabled neighborhoods in the city, Brier Hill, like Monkey's Nest, became a portal neighborhood for a wide variety of ethnic groups. And also like Monkey's Nest, most of the historic fabric of Brier Hill was destroyed during the era of urban renewal in the 1960s. But both neighborhoods have devoted groups of former residents who gather yearly to keep the spirit of the old neighborhoods alive.

As with Monkey's Nest, the origin of the name Brier Hill is debatable. In the 1920s, S.A. Brierly, whose father once owned land in the area next

to David Tod, explained that the neighborhood's name came from his family name. According to the story, it was nearly called either "Tod Hill," "Todville" or "Todburg," all in honor of David Tod. Instead, according to Brierly, it became known as Brier Hill in honor of his father. Industrialist Joseph Butler Jr. claimed a much different version of the story. "If my memory is reliable, Brier Hill got its name from the fact that the hill was covered with brambles and briers and was known to every barefooted boy who essayed to pick berries there," Butler said.[126]

Brier Hill might have been named for its brambles and briers, but it became known for coal, iron and steel. It would become, according to cultural geographer William Hunter, "perhaps one of the most historically meaningful places in Ohio, an area that is unquestionably significant for its role in the rise of the United States as an industrial power."[127] Future Ohio governor David Tod owned the original land on the hill. Tod's early farm became transformed upon the discovery of rich veins of coal, which was dubbed "Brier Hill black." These valuable deposits soon became sought-after for use in smelting in the local iron industry, especially as the Pennsylvania and Ohio Canal greatly improved the area's transportation capabilities after 1839.[128]

By the twentieth century, great blast furnaces dominated the landscape of Brier Hill, but the first primitive iron furnaces built in the 1840s held none of the same grandeur. Yet they attracted immigrants by the droves to the burgeoning industrial center. The first Welsh immigrants began arriving in Brier Hill in 1847. A Welshman erected the first blast furnace in the area, the Eagle Furnace. However, the majority of the early Welsh settlers mined coal. Many arrived by way of Brady's Bend on the Allegheny River. Irish, Germans (many of whom were Jewish) and Scandinavian immigrants soon followed the Welsh.

Brier Hill remained a village outside Youngstown until the city annexed the area in 1889. As the neighborhood developed, the boundaries of Brier Hill became, roughly, Gypsy Lane and Sarah Street to the north, Belmont Avenue to the east, Madison Avenue to the south and West Federal Street to the west. Many of the neighborhood's street names (Norwood, Calvin, Victoria, Oxford, etc.) are of English origin, but they were originally German names (Calvin Street was once known as German Street), all of which changed during World War I.

A wide variety of churches, which often served as ethnic community centers, marked the landscape of Brier Hill. The second-oldest Catholic parish in the area was formed by a predominately Irish congregation in 1869–70. St. Ann's Roman Catholic Church originally opened as a storefront

St. Ann's Church remained one of Brier Hill's most important landmarks until it was razed during urban renewal in 1960. *Courtesy of the author.*

COMMUNITIES OF THE PAST

church at the corner of Calvin and West Federal Streets. (Calvin Street was later shortened during urban renewal.) It marked the real beginning of organized Catholic parishes in the area.

The original Catholic masses in Brier Hill took place in individual homes. When St. Ann's was dedicated in 1870, it primarily served Catholics from Brier Hill, Girard and Mineral Ridge. St. Ann's Parochial School was the first modern school in the neighborhood when it opened in 1870. The congregation purchased land and began construction of the new church at the corner of West Federal and Jefferson Streets in 1892. The disastrous financial panic of 1893 delayed the final opening and dedication of the church for well over a decade. During that period, an Italian Congregation bought the old St. Ann's Church, which became St. Anthony of Padua.

The new St. Ann's that finally opened in June 1906 was a Gothic masterpiece, one of the finest churches in the Mahoning Valley. Made of brick and sandstone, it radiated a distinctly European feel. The two prominent bell towers (one 150 feet high and the other 115) also echoed the architecture of the Old World, and the church's tall spire instantly became one of the major landmarks of West Federal Street. Fourteen large stained-glass windows, each bearing two saints, graced the building. The dramatic arches inside the interior were festooned with lights, as were the reredos behind the altar. As the church grew into the new building, it attracted Catholics from Brier Hill and Monkey's Nest, including the Irish (predominately), Mexicans and some Italians.

Frances Prayor Singleton's family was one of two black families to regularly attend St. Ann's. "My mother took her first communion there in 1929, and my parents were married at St. Ann's in 1938," she said. "I can remember the priests and the nuns would come out and play ball with us when we were down there. The nuns would be out there with habits on and everything. And up the street on the same side was an Isaly's. If we were good in church, we could go up there and get some ice cream."

Isaly's was part of a well-developed business district that served the local Brier Hill area. "The West Federal Street area was a kind of closed community," according to Tom Ramos, who lived on Superior Street in Brier Hill. "Most of the people, if you lived there for a while, knew who you were. We had Graef's Window there, Isaly's, a drugstore, a post office, a radio shop and several dry cleaners."

The nearby Fox Theater served the community's entertainment needs. The Fox was originally known as the Victory Theater when it opened around 1920. "Neighborhood theaters were very popular during that time," Ramos recalled. "The Fox had one screen and could maybe seat a few hundred people."

LOST YOUNGSTOWN

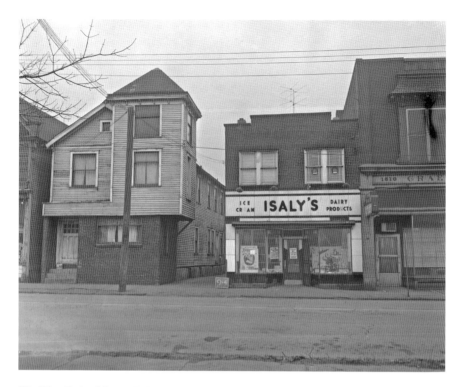

The West Federal Street Isaly's in Brier Hill, circa the late 1950s. *Courtesy of Mahoning Valley Historical Society.*

"We used to go there all of the time," Helen Tatarka said. "Only one movie played each week. If it was a serial, like *Flash Gordon*, then you had to wait until the next week for the new installment. The Brier Hill kids and kids from Monkey's Nest all went to the Fox."

Although Brier Hill did not start as an Italian community, it eventually became known as Italian Brier Hill or "Youngstown's Little Italy," as it is often referred to today. The first Italian immigrants came to Youngstown to work in the iron furnaces in the latter half of the nineteenth century. Most of these newcomers hailed from southern Italy. By the 1920s, Welsh and German immigrants were leaving Brier Hill, and the neighborhood gradually became more of (but not exclusively) an Italian enclave.

Predominately Italian churches like St. Anthony's and St. Rocco's Church, which was formed by former congregants from St. Anthony's, became central to neighborhood life. And Italians brought many of the aspects of communal village life with them to Brier Hill, creating Italian cultural societies and organizations like the Brier Hill Athletic and Civic Association.

COMMUNITIES OF THE PAST

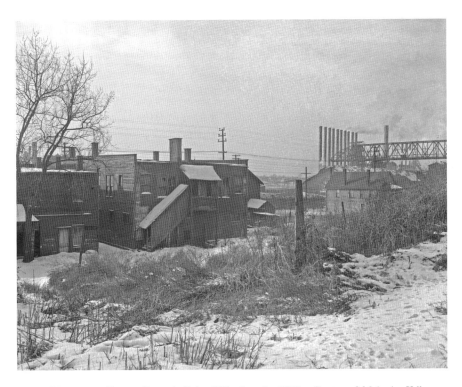

View of houses on Spruce Street in Brier Hill, circa the 1950s. *Courtesy of Mahoning Valley Historical Society.*

Despite much of the economic hardship of growing up on the hill, these ties kept neighbors going.

"You know how people were like to someone like my family," Josephine Ross later recalled. "They would come over with a little thing of coal, and they'd say 'We're going to come and visit, and we just thought we would make it warm.' You know, [they were] giving us coal, but not wanting to give it to us."[129]

During the Depression years, many Italian families subsisted on the produce from large family gardens. Steelworkers even brought home old firebricks from the blast furnaces and built outdoor communal ovens, which were scattered throughout the neighborhood. "My mother used to raise chickens and rabbits," Antionetta Mary Julian Sapio said. "We used to bake bread. We had a large outdoor oven, and the bread smelled all over Dearborn Street."[130]

The Brier Hill Italian community also produced several notable politicians, including former Youngstown mayors Anthony B. Flask and

The vacant Modarelli's Market is one of the remaining landmarks of the old Brier Hill neighborhood. *Photo by the author.*

James Philip Richley. Italian business owners prospered in the Brier Hill area as well. Kayo's Bar (now Italian American Club, Post 12), Modarelli's Market on Dearborn Street and Rimedio's grocery store all became Brier Hill landmarks. The Gaytime Café, located on West Federal Street, also became a prominent watering hole. Customers could order spaghetti and meatballs for thirty-five cents, steak marinated with wine and mushrooms for sixty cents or a "black gold" sausage sandwich for ten cents, all while being entertained by local groups like the Hawaiian Troubadours or the Charlotte brothers themselves, who also owned the establishment.

The world of Brier Hill, however, began to unravel at the end of the 1950s. In 1953, the city proposed to straighten and widen the stretch of West Federal Street (to be completed by the end of the decade) starting from near Westlake Terrace to the city limits. Planners estimated that at least 350 homes and an unknown number of businesses would have to be demolished.[131] This was seen as part of the first step of tying in West Federal Street (soon to be U.S. Route 442) with the future plans for the arterial highway system around the city. The decision ultimately doomed St. Ann's (demolished and closed in 1960), St. Rocco's (relocated to Liberty Township in 1957) and St. Anthony's (relocated to Turin Avenue).

COMMUNITIES OF THE PAST

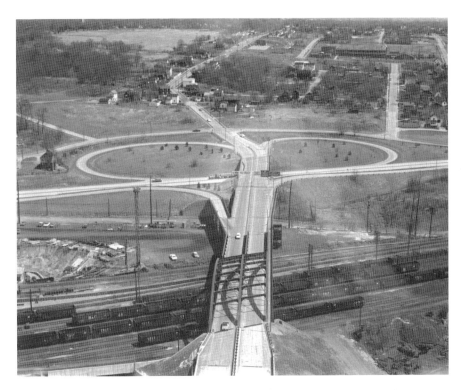

A large piece of Brier Hill was removed to make way for the Division Street Expressway and the clover leafs of U.S. Route 422. St. Anthony's Church (visible in the upper right) was rebuilt on Turin Avenue in 1959 after being forcibly moved by the expressway projects. *Courtesy of Thomas Molocea.*

The commercial section of Brier Hill and West Federal Street also greatly suffered. "That took the heart out of the neighborhood," former area resident Father Joseph Rudjak noted. "That meant we had to walk to Belmont Avenue in order to get any services. Before we walked three blocks over. There were churches, bakeries and a theater [the Fox]. Isaly's was there, clubs and various other functions."

In 1954, an urban renewal bond issue passed, which ultimately doomed Monkey's Nest along with stretches of homes and businesses near West Federal Street between Wirt Street and Robinwood Avenue in Brier Hill. The city purchased the land and cleared all residents from Monkey' Nest by the early 1960s. Redubbed "Riverbend," the old neighborhood became a light industrial area.

The U.S. Route 422 projects, the arterial highway system and, later, the 711 connector, erased much of historic Brier Hill. "The neighborhood that

was Monkey's Nest is also gone," Steve Ramos, whose family had deep roots in Brier Hill, later noted. "Its houses and businesses replaced with warehouses and factories…More importantly, the Brier Hill Works, the lifeblood of the neighborhood, is gone."[132]

The spirit of the old neighborhoods lives on, however. Beginning in 1977, former residents of Monkey's Nest began organizing yearly reunions. The widely scattered families gathered to eat, catch-up and remember old times and faces long gone. Almost fifty years after the neighborhood's demise, the reunions continued. "Children and even grandchildren started attending," said Helen Tatarka, who chaired the reunions for several years. "They eventually started holding them at the Croatian Home on the west side."

The first Brier Hill neighborhood reunions began in the 1970s, drawing hundreds back to the hill annually. In 1991, former residents, led by Dominic "Dee Dee" Modarelli and Tony Trolio, inaugurated the first annual Brier Hill Italian Fest. For nearly a quarter century since, old residents—and those who have no historical memory of old Brier Hill—have come to the corner of Calvin and Victoria Streets to eat, dance and celebrate Italian American culture. It is now perhaps the most popular festival held in the city.

It is difficult today to recognize much of the former West Federal Street, Brier Hill, Monkey's Nest and Westlake Crossing. But while the physical landscape is forever changed, the memory of businesses and neighborhoods remain indelibly etched in the historical memory of Youngstown. As former Brier Hill resident Fred Ross once acknowledged, "Sure it's gone, but it will always be there."[133]

8
SMOKY HOLLOW

In the shadow of a large parking deck, Harrison Common sits near the heart of what was once the neighborhood of Smoky Hollow. The common contains green space, a small brick plaza, an arbor, a replica of a communal bread oven and a map of the neighborhood's old institutions. Beyond the common, only an occasional house punctuates a quiet, slowly greening area of old brick streets.

The area's sleepy presence belies its historic past as one of the city's most well-known neighborhoods. A working-class enclave at the edge of downtown, Smoky Hollow served (much like Brier Hill, Monkey's Nest and other similarly communities) as a portal neighborhood for a variety of immigrant groups. Everyone from gangsters to doctors, to the legendary film titan Jack Warner, and the country's leading mall developer, Edward J. DeBartolo Sr., came from the Hollow. "It had all the good qualities of an intimate village," according to local historian Ben Lariccia. "It was actually a city within a city."

Playwright Rob Zellers adapted Smoky Hollow as a backdrop for a fictional play set in the nineteenth century. "If you are going to study the history of metal, iron, and steelmaking here, then as you walk through history, Smoky Hollow is going to appear…It's an important part [of] our local lore," Zellers explained.

Smoky Hollow's origins date back to around the 1870s. The first streets in the area were platted during that decade, and large numbers of Irish immigrants were among the first settlers in the area.[134] The Irish—many of

LOST YOUNGSTOWN

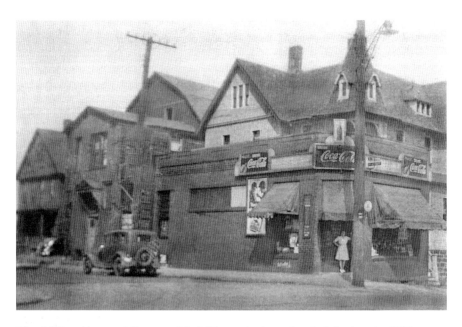

The childhood home of film mogul Jack Warner is pictured at far left, circa the 1920s or 1930s. *Courtesy of Joseph J. Cassese.*

whom came to work on the Pennsylvania and Ohio Canal and in the mines and early iron furnaces—settled in places like Vinegar Hill (near Shehy Street), Bottle Hill (on the lower east side), Kilkenny (near Poland Avenue) and in the Hollow.

Newcomers to Smoky Hollow often worked in the local iron industry, where they faced frightful conditions on the job and at home. According to Rob Zellers, "Ironworkers were some of the first workers to settle in the Hollow. There was an area of the neighborhood known as 'Misery Row' for its awful housing, and disease would periodically wipe out large numbers of people in the late nineteenth century, especially smallpox."

The deplorable conditions gradually improved in the early twentieth century as the neighborhood began to fill out. The Hollow came to be bounded by Walnut Street, Crab Creek, Scott Street and Via Mount Carmel Avenue, home of Our Lady of Mount Carmel Church, established in 1908. It encompassed anywhere from seventy to seventy-five acres of land. Gradually, the area became increasingly Italian as the century progressed, but African Americans, Slovaks (served by nearby Saints Cyril and Methodius Church), Puerto Ricans, Greeks and Germans, among others, also came to call Smoky Hollow home.

COMMUNITIES OF THE PAST

Like many of the evocatively named neighborhoods in Youngstown, the exact origins of the name Smoky Hollow are unclear. According to former resident and journalist Edward Manning, "Smoky Hollow was at one time Wick Woods. Then later on they sold it out in lots. It was strictly a working man's neighborhood."[135]

Former resident Dominic Ciarniello described his theory of how the neighborhood came to be named: "Along Andrews Avenue at that time, there was still a big blast furnace, called Valley Mill, operating. And the heavy trains of coal that go up the track on Andrews Avenue up…along Crab Creek. You talk about pollution today; well you just can't imagine the pollution. When those heavy trains came puffing up the track, about a minute after they came into sight, you could feel the particles of dust falling…So that's the understanding that I have that Smoky Hollow really got its name."[136]

In any case, Smoky Hollow did become a working-class neighborhood. Many of the men in the Hollow came to work for General Fireproofing, Republic Rubber, Youngstown Sheet and Tube or one of the many other nearby manufacturing facilities. Like many other neighborhoods of the time, a tight bond of community obligation formed: neighbors gathered to celebrate weddings, help hold funerals, discipline children (not just their own) and look in on sick neighbors. It was not uncommon for people to have skeleton keys, which opened other houses on their street, in case of emergency.

Homes in the Hollow were generally small and quite plain. Over the years, many of the skilled tradesmen made additions to their homes; some even built their own houses. It wasn't uncommon for families to spend summers in their basements, due to the heat, and to spend winters shoveling coal into their furnaces.

Much like Brier Hill, communal bread ovens played a large role in the community. Gale Mills explained:

> *These ovens, some of them were built square and some had the rounded top, like a Roman arch. They would build a fire inside of the little kiln-like structure. When the bricks were hot, then they would scrape out the fire and on flat boards put the mounds of bread dough, shove* [them] *into the oven and block up the front. Almost by magic, those loaves would come out golden brown and swollen up beautifully. On a given day—I believe Wednesday was one of those days they would bake—the whole neighborhood would smell of fresh bread.*[137]

LOST YOUNGSTOWN

Communal life came center stage on a common green space set amid the densely packed blocks of the Hollow. "The playground—Harrison Field—was a big attraction in Smoky Hollow," Dominic Ciarniello remembered. "I think sports was [sic] the greatest thing that brought all those ethnic groups together."[138]

The first softball teams in the area, with names like the Walnuts (for Walnut Street) and the Smoky Hollow Boys, cut their teeth at Harrison. Dominic Rosselli, the legendary coach who compiled one of the best records in NCAA history, was introduced to sports through the weekly baseball games there. The Golden Eagle Club, which later built the World War II memorial in the Hollow, started at Harrison during the Depression. Aside from weekly football and softball games, which could draw thousands, "washer" tournaments were also held at the field.

Patterned after horseshoes, the game of ringers (or washers, as it was originally called) was usually played with a four-inch-diameter pipe (or washer hole). Players would attempt to toss washers (around two and a half inches in circumference) into the pipe.[139] Both the washers and the pipe usually came from local steelworkers, who procured them from the mills, making it a perfect game for Smoky Hollow, and indeed, for the city at large. Informal and formal tournaments (the latter sponsored by the

Abandoned homes in Oak Park slowly return to nature. *Photo by the author.*

COMMUNITIES OF THE PAST

Youngstown Vindicator) took place at Harrison Field, drawing scores from the local neighborhood.

A new and unique addition to Smoky Hollow came in 1910. Designed by the Modern Homes Company of Youngstown, "Oak Park," as the development came to be called, was built near Andrews Avenue to provide healthy and sanitary living arrangements for laborers. The homes themselves represented a distinct local building method—poured concrete with hollow core tile.[140] The Oak Park homes faced one another across a long green space (complete with shade trees), which gave the area a decidedly bucolic feel. Modern furnaces, bathrooms and laundries were all located on the premises. The Concrete Stone and Sand Company, which supplied the materials, became internationally known for its work. The industry journal *Rock Products* referred to the Oak Park project and the Modern Homes Company as "one of the landmarks in the progress of the age."[141]

Former resident Bill George grew up in Oak Park during the 1950s and 1960s. "In the summer, if you had your television on, or if your neighbor had their television on, you could hear each other from next door," George explained. "Everyone in the neighborhood watched out for you. At

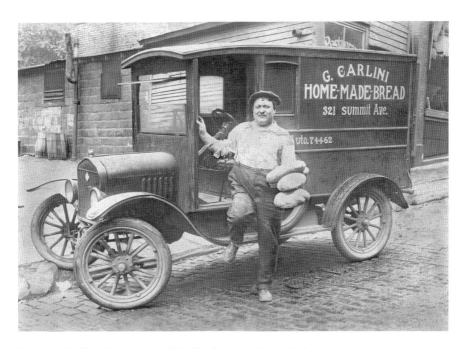

Bread truck, Watt Street, circa 1924–25. *Courtesy of Joseph J. Cassese.*

Christmas, if anyone had something to share, they'd share it. It was just that kind of area."

Like many neighborhoods in Youngstown, the 1950s and 1960s offered a memorable environment for growing up in, one that many former Hollow residents recall with fondness. "The neighborhood itself was so diverse," Guy DiPasqua recalled. "You had every ethnicity, so you had every type of food; you could smell it all day. Asian people were always cooking something good, and Mexican people were steaming rice."

Services of all kinds were never far away, either. "Halfway up Emerald Street, where I was born, was the Tip-Top Bar and the Pilolli Grocery store," explained Irene Economou. "Passed Kirkland Street on Walnut was Bill Wainio's store, and there was another grocery store on Walnut as you approached Rayen Avenue. The library, churches, corner stores and the downtown shopping district were all within walking distance."

As in much of Youngstown, corner grocery stores played a special part in the fabric of neighborhood: they served as meeting spots; local grocers supplied credit, especially during strikes and downswings in the local steel industry; and business owners served as readily available examples of role models for young people. In the days before the arrival of A&P Supermarkets, corner grocers proliferated throughout the city. But between the end of World War II and 1970, 70 percent of Youngstown's neighborhood grocers closed—changing the face of many residential areas, including the Hollow.[142]

The 1950s also brought the beginning of urban renewal to the Hollow, the first step in the eventual decay of the neighborhood. "Now when you drive to the MVR [the Mahoning Valley Restaurant], you go down," explained Ben Lariccia. "At one time, prior to 1956 or 1957, East Rayen Avenue was as low as Walnut Street. The city decided to tear down all the businesses in what was essentially the business district of the Hollow. They tore all of that down and filled it in using the power of eminent domain."

In the 1960s, the city planned for a new leg of the expressway to go through the Hollow. A large piece of Oak Park, a portion of Emerald Street and all of Kirtland Street were removed. At the same time, increasing numbers of residents began to leave the Hollow. "As the children of families left to pursue their educations, there weren't enough people to take over the houses from the older generation," Irene Economou explained. "Younger people who stayed in the area moved into bigger houses elsewhere."

As the neighborhood entered the 1970s, artists, local hippies and university students began to enter the Hollow. "Some of the houses were run down, but the neighborhood was still largely intact at that point," former

COMMUNITIES OF THE PAST

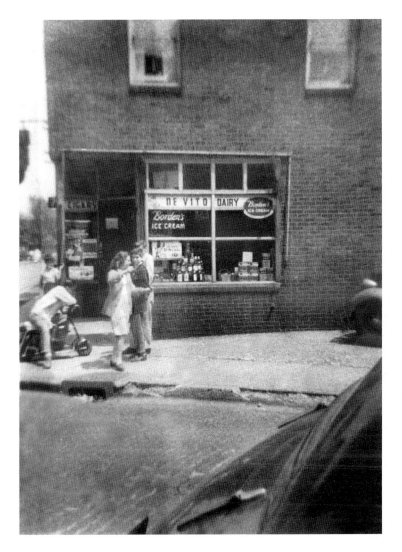

Devito Dairy, Emerald Street. *Courtesy of Joseph J. Cassese.*

resident Patrick Ridder remembered. "If you went to a place like the Tip-Top Bar, you'd see a very interesting mix of steelworkers, artists, guys from GM, and college students."

Rebecca Banks grew up in the Hollow in the late 1960s and into the late 1970s. Some of the rhythms of life remained the same. "One of our neighbors had roosters and chickens, and there were fruit trees nearby…The Urban League had its office down there, and the Tip-Top was on the corner," Banks said. The neighborhood's reputation had changed, however. "When

LOST YOUNGSTOWN

An expressway service road removed a section of Oak Park in the 1960s. *Courtesy of the author.*

kids asked where I lived, and when I said the Hollow, they would say, 'You live in the bottoms!' That was the street name for the Hollow then."

By the 1970s, university parking lots began to pepper the area, and it was no secret that Youngstown State viewed the neighborhood as an outlet for future expansion. In 1976, the university started purchasing houses in the Hollow to make way for a large parking deck. Despite pushback from some residents, it became apparent that the project would go forward. The beginning of the end of the steel industry in 1977 furthered the Hollow's precipitous decline.

"The Hollow is dead," pronounced Carmine Cassese in 1989.[143] Ironically, Cassese's business, the Mahoning Valley Restaurant, today serves as the last reminder of the old neighborhood: a city institution that is now one of the oldest operating establishments in Youngstown. The MVR, as it is known, has gone from a small Smoky Hollow business to a university hangout and a gathering spot for generations of Youngstowners.

Carmine T. Cassese's MVR began in 1927 as a simple poolroom on Walnut Street. In order to make way for the building of the storefront, the Cassese family moved their house (using logs) from the front of the property to the back. When

COMMUNITIES OF THE PAST

Prohibition ended in 1933, the MVR (often known just as "Cassese's" then) obtained one of the first liquor licenses in the city. "It was a place where you would go and play some pool," current manager Joseph J. Cassese explained. "Since the house was right there, my great-grandmother would come by, and she'd bring some soup. And for five cents or so, you could get a bowl of soup."

According to Dominic Ciarniello, Carmine T. Cassese was known then as "the house man." "And anybody that needed anything would always go to the house man and he was always ready to help anyone," Ciarniello remembered. "He could always lend out a couple of dollars or sell you whatever you wanted. And you could spend some time playing cards or shooting pool there."[144]

From behind the mahogany bar, Carmine Cassese ran the bar with minimal help; however, as the decades passed, and as the MVR transformed into a full-service restaurant, it took the full help of several family members and more to keep up the business. During a rough period in the late 1960s and early 1970s, it seemed as if the MVR's future might be joined to that of the slowly decaying Smoky Hollow neighborhood itself. Yet the MVR not only survived but thrived. Carmine's son, Joe, and his son, Carmine L. Cassese, navigated the restaurant successfully through the 1980s. The restaurant expanded from one narrow bar to include two larger dining areas, extensive interior remodeling, and an outdoor patio with bocce courts. As the neighborhood faded away, the MVR became a prime university watering hole and a center for former residents who love to return and reminisce about the old neighborhood.

In 2013, Carmine L. Cassese passed away after a battle with pancreatic cancer. Today, his son Joseph J. Cassese carries on the family tradition—and with it, the memory of Smoky Hollow. Cassese explained: "I can't tell you how many times people have walked in through that door, and they might be ninety years old or they might be forty years old, but they have a tie to the Hollow."

In 2002, a partnership between Youngstown State University, St. John's Episcopal Church and a variety of stakeholders around Wick Avenue on the north side, began to take shape. In 2003, Wick Neighbors Incorporated, a nonprofit development corporation, formed to jumpstart the redevelopment of the Hollow. A plan soon emerged to turn the largely vacant neighborhood into a centerpiece of neighborhood development: new housing, retail, green space and various entertainment facilities would keep the new neighborhood activated twenty-four hours a day.

In 2010, the first part of the eventual rehabilitation project began: the old Harrison Field was redubbed "Harrison Common," and an arbor, a brick plaza, a map of the old institutions/businesses of the Hollow and a replica

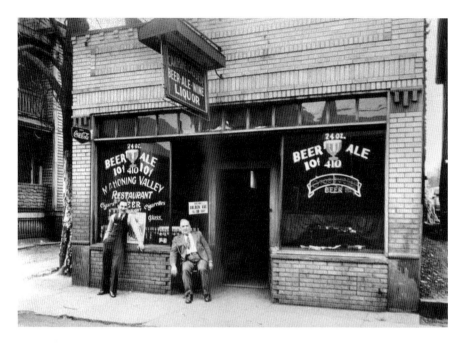

The Mahoning Valley Restaurant, circa 1940s. *Courtesy of Joseph J. Cassese.*

of an old communal bread oven were all built. The redevelopment of Smoky Hollow has yet to occur, however. Student housing now occupies the former Wick Oval area next door, but the Hollow itself remains quiet today.

"If you go the main entrance of Smoky Hollow where the [war] memorial is and read those names, that feeling of pride and dignity that went with those people is part of Smoky Hollow," explained former resident Gale Mills. "The Hollow turned out fine, prosperous businessmen, numerous professionals; it even turned out first grade hoodlums. They had that one thing in common, however, each one—professionals, businessmen, hoodlum—they boasted of belonging to the Hollow."[145]

The neighborhood of Smoky Hollow really did represent, in the truest sense, an urban village. Its qualities are reflected by the fact that so many of its former residents have a deep attachment to the area, despite the fact that the Hollow's historic fabric was erased years ago. Like the other classic neighborhoods of Youngstown, it served as an environment of purpose and meaning, even if material conditions were not equal to those of today. Because of this, those who grew up in Smoky Hollow retain their fond memories of the area and consider it a place that nurtured their character and spirit—a place they are not soon likely to forget.

NOTES

Introduction

1. *Youngstown Vindicator*, "Mahoning Valley Included in Volume on Early Ohio," September 26, 1942.
2. Eleanor Roosevelt, "My Day," *Youngstown Vindicator*, October 30, 1939, 1.
3. George E. Reiss, "City Today Ranks Fourth in Nation's Steel Output," *Youngstown Vindicator*, January 29, 1950, D-2.
4. Vergara, Tracking Time.
5. Hayden, *Power of Place*, 47.

Chapter 1

6. Ernest N. Nemenyl, "Industry's History Extols Iron Men," *Youngstown Vindicator*, March 27, 1938.
7. *Youngstown Vindicator*, "Puddling Is a Lost Art," January 30, 1931.
8. See *Youngstown Vindicator*, "Hospital Opens Monday," November 21, 1915; Ohio History Collection, "Youngstown Sheet and Tube Architectural Rendering," 1915.
9. Ruminski, "Death, Technology, and the Rise of Steel."
10. Linkon and Russo, *Steeltown USA*, 28–29.
11. Whipple, "146 Unit-Built Concrete Dwellings at Youngstown."
12. Linkon and Russo, *Steeltown USA*, 25.

13. Aley, *Heritage to Share*, 316.
14. Ernest N. Nemenyl, "Expect New S-T Mill to Bring More Business," *Youngstown Vindicator*, April 25, 1938.
15. Ibid., "7,000 Steel Men Benefit in New Plan," *Youngstown Vindicator*, June 30, 1935.
16. Ingham, *Iron Barons*, 197, 202.
17. Meub, interview by Janice Cafaro.
18. Office of War Information, "Steeltown."
19. Pace and Associates, *Comprehensive City Plan, Report No. 1*, 23–24.
20. Fuechtmann, *Steeples and Stacks*, 26.
21. Becker and McClenahan, *Eisenhower and the Cold War Economy*, 169.
22. *Youngstown Vindicator*, "Sheet and Tube's New Pipe Mill," September 5, 1957.
23. Ibid., "Says Unity Is Needed to Get Canal," June 14, 1961.
24. George R. Reiss, "Glossbrenner Sets August Bill as Goal," *Youngstown Vindicator*, January 15, 1962.
25. Clingan Jackson, "McDonald Says Canal Will Aid Tri-State Area," *Youngstown Vindicator*, March 26, 1962.
26. *Youngstown Vindicator*, "Kirwan Denies Canal Is Only for Youngstown," September 18, 1966.
27. Ibid.
28. *Bulletin*, "Colorful Mark of Steel," February 1963, 18.
29. Horvatt, interview by Mary Kay Schultz.
30. Meub, interview by Janice Cafaro.
31. Hall, *Steel Phoenix*, 68.
32. T.V. Petzinger Jr., "Save Our Valley Crusade Operates from Storefront," *Youngstown Vindicator*, March 19, 1978, 1.

CHAPTER 2

33. Butler, *History of Youngstown*, 730.
34. C.H. Zieme, "The Republic Rubber Company," *Youngstown Vindicator*, February 11, 1925, 2.
35. Skrabec, *Rubber*, 51–52.
36. Ibid.
37. Zieme, "Republic Rubber Company."
38. Republic Tires, Staggard Tread, advertisement, *Sunset Magazine*, 1915.
39. Butler, *History of Youngstown*, 730.
40. "Clubhouse for Working People," *Automobile*, 632–33.

NOTES TO PAGES 42–63

41. C.M. Croyer, "Church Tells of Employees' Club," *Spokane Daily Chronicle*, January 31, 1914.
42. National Housing Association, *Proceedings of the Sixth National Conference on Housing*, 1917.
43. *Youngstown Vindicator*, "Republic Co. Launches Week," June 17, 1922.
44. Ibid., "White House Commends Week," June 14, 1922.
45. Tully, *Devil's Milk*, 162.
46. *Youngstown Vindicator*, "Ford to Enter Bidder's Ranks for Rubber Co.," March 12, 1923, 1.
47. Ibid., "Local Rubber Plant Is Sold to Eastern Men," May 23, 1923.
48. Ibid., "Rubber Plant Here Makes New Rug, Plan 3,000 Daily Output," April 2, 1929.
49. *Valley Foreman*, "Company of the Month," December 1947, 6.
50. Ibid.
51. *Youngstown Vindicator*, "Republic Here Helps Make New Ship One of the Safest," August 7, 1952.
52. Ibid., "Aeroquip Corp. Faces Shutdown," April 10, 1978.
53. Ibid., "Republic Hose Will Open in 2 Weeks, Employ 150," April 20, 1979, 1.
54. Paul Hurley, "Worker-Owned Firm Flourishes," *Youngstown Vindicator*, June 16, 1980, 8.
55. *Youngstown Vindicator*, "Republic Hose: Employee Owned Success," April 17, 1984.
56. Ibid., "Declining Dollar Aids Republic Hose," March 24, 1987, 1.

Chapter 3

57. Charles A. Leedy, "Theater Now Holds Site of Caleb B. Wick Home," *Youngstown Vindicator*, March 3, 1940.
58. *Youngstown Vindicator*, "Many Names for New Theater," December 21, 1916.
59. Ibid., "Film Shows How Youngstown's Playhouse Was Built in Wartime," February 10, 1918, 8-B.
60. Hynes, interview by Carol Shaffer Mills.
61. *Youngstown Telegram*, "Liberty Theater Fitting Shrine for Silent Art," February 9, 1918.
62. *Youngstown Vindicator*, "Film Shows How Youngstown's Playhouse was Built in Wartime."

63. *Youngstown Telegram*, "Liberty Theater Welcomes Crowds," February 12, 1918.
64. Hynes, interview by Carol Shaffer Mills.
65. Manning, interview by D. Scott Van Horn.
66. *Youngstown Vindicator*, "Hundreds Jam New Theater," July 20, 1929.
67. Charles A. Leedy, "Youngstown Show Center When There Were Shows; Now Movies Hold Sway," *Youngstown Telegraph*, June 29, 1931.
68. McDermott, "Paramount Project Voices II."
69. *Youngstown Vindicator*, "New Paramount Will Have Formal Opening Friday," March 8, 1951, 39.
70. Ibid.
71. Jacobs, "Paramount Project Voices II."
72. Russell, "Paramount Project Voices IV."
73. Pace and Associates, *Comprehensive City Plan, Report No. 1*, 37.
74. Janie S. Jenkins, "Stardust Sparkles at Premier for 'Biff,'" *Youngstown Vindicator*, February 26, 1966, 2.
75. Fred Childress, "Paramount Closing Leaves Youngstown Without First-Run Theater," *Youngstown Vindicator*, September 22, 1970.
76. Rausch, Walker and Watson, *Reflections on Blaxploitation*, ix.
77. Tim Roberts, "$500,000 Goal for 2 Projects," *Youngstown Vindicator*, May 28, 1983, 17.

Chapter 4

78. *Youngstown Vindicator*, "A Utilitarian Dream for Market Street," July 11, 1981.
79. *Business Journal*, "Bridge Brought Growth to Market Street," May 1997, 15.
80. *Youngstown Vindicator*, "Market Street Coming to the Front as a Business District," March 31, 1912, B-4.
81. Ibid., "South Side Starts to Blossom Out," March 27, 1938.
82. Ibid., "New Stores to Build in 'Uptown,'" December 14, 1937.
83. Ibid., "Court Orders Shop Center to Be Halted," November 14, 1947.
84. Ibid., "Miniature Jungle Inn," editorial, July 15, 1957.
85. Ibid., "Franko Quits Bench 30 days to Campaign," October 8, 1959, 13.
86. Morgan and Welsh, *Classic Restaurants of Youngstown*, 80.
87. May, *Crimetown U.S.A.*, 321.
88. *Youngstown Vindicator*, "More City Shoppers Favor Outlying Centers," April 7, 1957.
89. Pace and Associates, *Comprehensive City Plan, Report No. 1*, 36.

NOTES TO PAGES 89–119

90. *Youngstown Vindicator*, "Chains Squeeze Out Isle of Capri," February 24, 1994, C-4.
91. Ibid., "Dimout Is Seen Boosting Crime," August 6, 1981, 40.
92. Ibid., "Market Street Leads Two Different Lives," October 15, 1989, 1.
93. *Box Office Magazine*, May 1, 1967, 1.
94. Morgan and Welsh, *Classic Restaurants of Youngstown*, 81.
95. Mark Niquette, "The Oven Heats Up Survival Plan," *Youngstown Vindicator*, March 6, 1994.

Chapter 5

96. *Youngstown Vindicator*, "Gets Permit for Academy," May 13, 1921.
97. The Bott Dancing Academy, "Will Occupy the New Building at 529 Elm Street This Week," advertisement, *Youngstown Vindicator*, October 2, 1921.
98. Giordano, *Satan in the Dance Hall*, 180.
99. Carney, interview by Philip Bracy.
100. *Youngstown Vindicator*, "By Their Dancing Shall, Ye Shall Know Them," September 30, 1934.
101. Carter, interview by Joseph Drobney.
102. Darlene Jeter, "Black Heritage Event to Honor Promoter," *Youngstown Vindicator*, November 4, 1996, B-4.
103. Ibid.
104. Stowe, *Swing Changes*, 8.
105. Behrens, *Big Bands and Great Ballrooms*, 30.
106. John Goodall, "Fairness Brought Promoter Success," *Youngstown Vindicator*, October 18, 1992, B-1.
107. *Youngstown Vindicator*, "Valley Radio Enters Eighth Decade," September 26, 1996, C-1.
108. Schenold, "Interview with Dick Biondi."
109. *Steel Valley News*, "Lincoln Ave. Landmarks to Fall in YU Expansion," September 23, 1964.

Chapter 6

110. *Youngstown Vindicator*, "Will Erect Big Theater," August 2, 1941.
111. Ibid., "Boardman Has Rapid Growth," January 14, 1942.
112. *Times News*, "Jeans Said Wrong for Theater Wear," December 22, 1958.

113. *Youngstown Vindicator*, "Homeowners Strive to Put Area on Register," July 29, 1996, B-1.

Chapter 7

114. Ibid., "Picturesque Local Names," January 30, 1916.
115. Karas, "Caldwell History," 1935.
116. Ernest Brown Jr., "Chic It Wasn't, but Monkey's Nest Was Home, and More, to Its People," *Youngstown Vindicator*, August 14, 1977, B-3.
117. Sharo, "Monkey's Nest."
118. Karas, "Caldwell History," 10.
119. Blakeny, interview by Michael Beverly.
120. Nicholson, *Ella Fitzgerald*, 107.
121. Lottier, interview by Jeffery Collier.
122. Youngstown Metropolitan Housing Authority, *Postwar Improvements*.
123. Clingan Jackson, "Mrs. Roosevelt Interested in Housing Project Details," *Youngstown Vindicator*, October, 28, 1939, 1.
124. *Youngstown Vindicator*, "Kirwan Says Westlake Sets Model for Nation," January 14, 1940, 1.
125. Youngstown Metropolitan Housing Authority, *Postwar Improvements*, 13–14.
126. *Youngstown Vindicator*, "Family or Berry Patch? How Brier Hill Was Named," February 2, 1925.
127. See Linkon and Russo, *Steel Town USA*, 242; Hunter, "Brier Hill Report."
128. Rogers, *Worker Housing Neighborhood Survey*, 72.
129. Ross and Ross, interview by Thomas Welsh.
130. Sapio, interview by Molly A. McNamara.
131. *Youngstown Vindicator*, "Relocating West Federal Street," April 14, 1953.
132. Ramos, "Father's Tale."
133. Thomas Ott, "Brier Hill Holds 9th Reunion," *Youngstown Vindicator*, March 10, 1985, A-6.

Chapter 8

134. Rogers, *Worker Housing Neighborhood Survey*, 15.
135. Manning, interview by D. Scott Van Horn.
136. Ciarniello, interview by Annette D. Mills.

137. Mills, interview by Annette Mills.
138. Ciarniello, interview by Annette D. Mills.
139. Lariccia, *Ringers/Washer*.
140. Rogers, *Worker Housing Neighborhood Survey*, 92.
141. "Structural Tile," *Rock Products*, 37.
142. Bluc, Jenkins, Lawson and Reedy, *Mahoning Memories*, 44
143. Norman Lee, "Club Displays Stamina," *Youngstown Vindicator*, November 19, 1989, 1.
144. Ciarniello, interview by Annette D. Mills.
145. Mills, interview by Annette Mills.

BIBLIOGRAPHY

Books

Aley, Howard C. *A Heritage to Share: The Bicentennial History of Youngstown and Mahoning County, Ohio: Youngstown and Mahoning County, Ohio, from Prehistoric Times to the National Bicentennial Year.* Youngstown, OH: Bicentennial Commission, 1975.

Becker, William H., and William M. McClenahan Jr. *Eisenhower and the Cold War Economy.* Baltimore, MD: Johns Hopkins University Press, 2011.

Behrens, Jack. *Big Bands and Great Ballrooms: America is Dancing…Again.* Bloomington, IN: Author House, 2006.

Blue, Frederick J., William D. Jenkins, William Lawson and Joan M. Reedy. *Mahoning Memories: A History of Youngstown and Mahoning County.* Virginia Beach, VA: Donning Company Publishers, 1995.

Butler, Joseph, Jr. *History of Youngstown and the Mahoning Valley.* Chicago: American Historical Society, 1921.

Fuechtmann, Thomas G. *Steeples and Stacks: Religion and Steel Crisis in Youngstown, Ohio.* Cambridge, UK: Cambridge University Press, 1989.

Giordano, Ralph G. *Satan in the Dance Hall: Rev. John Roach Straton, Social Dancing, and Morality in 1920s New York City.* Lanham, MD: Scarecrow Press, 2008.

Hall, Christopher G.L. *Steel Phoenix: The Fall and Rise of the U.S. Steel Industry.* New York: St. Martin's Press, 1997.

Hayden, Dolores. *The Power of Place: Urban Landscapes as Social History.* Cambridge, MA: MIT Press, 1997.

BIBLIOGRAPHY

Ingham, John N. *The Iron Barons: A Social Analysis of an American Urban Elite, 1874–1965*. Westport, CT: Greenwood Press, 1978.

Linkon, Sherry L., and John Russo. *Steel Town USA: Work and Memory in Youngstown, Ohio*. Lawrence: University of Kansas Press, 2002.

May, Allan R. *Crimetown U.S.A.: The History of the Mahoning Valley Mafia*. Cleveland, OH: Conallan Press, 2013.

Morgan, Gordon F., and Thomas Welsh. *Classic Restaurants of Youngstown*. Charleston, SC: The History Press, 2014.

Nicholson, Stuart. *Ella Fitzgerald: A Biography of the First Lady of Jazz*. Updated edition. New York: Routledge, 2004.

Rausch, Andrew J., David Walker and Chris Watson. *Reflections on Blaxploitation: Actors and Directors Speak*. Plymouth, MA: Scarecrow Press, 2009.

Schroeder, Gertrude. *Growth of Major Steel Companies, 1900–1950*. Baltimore, MD: Johns Hopkins University Press, 1953.

Skrabec, Quentin R., Jr. *Rubber: An American Industrial History*. Jefferson, NC: McFarland & Company, Inc., 2014.

Stowe, David W. *Swing Changes: Big-Band Jazz in New Deal America*. Cambridge, MA: Harvard University Press, 1994.

Tully, John. *The Devil's Milk: A Social History of Rubber*. New York: Monthly Review Press, 2011.

COMMISSIONED REPORTS

Hunter, William M. "Brier Hill Report: A Website Summary for the General Public." Center for Working Class Studies, Youngstown State University, Youngstown, OH, June 2000.

Pace and Associates. *Comprehensive City Plan, Report No. 1*. Chicago, IL, 1951.

Rogers, Rebecca M. *Worker Housing Neighborhood Survey*. Youngstown, OH: Community Development Agency, 1992.

INTERVIEWS

Allen, Martel Davis. Interview by the author, December 2014.
Attenberger, Donald. Interview by the author, August 2014.
Bancroft, Kelly. Interview by the author, July 2015.
Banks, Rebecca. Interview by the author, August 2015.
Bigelow, Robert. Interview by the author, April 2015.

BIBLIOGRAPHY

Cassese, Joseph J. Interview by the author, May 2015.
Chrystal, Jeff. Interview by the author, February 2015.
Corcoran, Jerome. Interview by the author, March 2015.
DeCicco, Bill. Interview by the author, August 2015.
Dill, Bruce. Interview by the author, January 2015.
Economou, Irene. Interview by the author, April 2015.
Flaviano, Ron. Interview by the author, April 2015.
George, Bill. Interview by the author, December 2014.
Hancock, Todd. Interview by the author, June 2015.
Hanni, Don, III. Interview by the author, May 2015.
Kerrigan, Patrick. Interview by the author, October 2014.
Kovalchik, Bill. Interview by the author, March 2015.
Lariccia, Ben. Interview by the author, October 2014.
Markulin, Joe. Interview by the author, January 2015.
Martin, Tonya. Interview by the author, December 2014.
Meshel, Harry. Interview by the author, May 2015.
Moore, James. Interview by the author, March 2015.
Moore, Liz. Interview by the author, February 2015.
Pacic, Edo. Interview by the author, February 2015.
Parker, Nadine. Interview by the author, July 2015.
Peyko, Mark. Interview by the author, September 2014.
Pillot, Jeff. Interview by the author, June 2015.
Poindexter, Jerry. Interview by the author, September 2014.
Posey, Fred. Interview by the author, July 2015.
Quaranta, Anna Marie. Interview by the author, August 2014.
Ramos, Tom. Interview by the author, January 2015.
Reuter, Cathy. Interview by the author, August 2014.
Roncone, Mike. Interview by the author, April 2015.
Rudjak, Joseph S. Interview by the author, March 2015.
Ruminski, Clayton. Interview by the author, April 2015.
Scarsella, Richard. Interview by the author, June 2015.
Sinchak, Del. Interview by the author, February 2015.
Singleton, Frances Prayor. Interview by the author, August 2015.
Soni, Betty Peters. Interview by the author, February 2015.
Tatarka, Helen. Interview by the author, March 2015.
Thomas, Gerryanne. Interview by the author, April 2015.
Umbel, Bill Interview by the author, August 2014.
Vargo, Bob. Interview by the author, July 2015.
Zellers, Rob. Interview by the author, August 2014.

BIBLIOGRAPHY

Magazine and Journal Articles

Box Office Magazine, May 1, 1967.
"A Clubhouse for Working People." *Automobile* 30, no. 12 (March 1914): 632–33.
"Structural Tile." *Rock Products* 9, no. 12 (June 1910): 37.
Whipple, Harvey. "146 Unit-Built Concrete Dwellings at Youngstown." *Concrete-Cement Age* 12, no. 2 (January 1918): 5

Newspapers

Bulletin (Youngstown Sheet and Tube newsletter).
Business Journal (1997).
Hendersonville-Times News (1958).
Pittsburgh Courier (1936).
Pittsburgh Press (1931).
Spokane Daily Chronicle (1914).
Steel Valley News (1964).
Youngstown Telegram (1918, 1931).
Youngstown Vindicator (1912–96).

Online Multimedia Files

Jacobs, Bob. "Paramount Project Voices II." McDonough Museum of Art, Youngstown, OH. https://www.youtube.com/watch?v=eL91vB7cf3k.
Lariccia, Ben. *Ringers/Washers: A Youngstown Game*. Steel Valley Voices, YSU Center for Working Class Studies, 2010. https://www.youtube.com/watch?v=6-fwjDaF4i8.
McDermott, Robert. "Paramount Project Voices II." McDonough Museum of Art, Youngstown, OH. https://www.youtube.com/watch?v=eL91vB7cf3k.
Office of War Information. "Steeltown." Center for Working Class Studies. Video player file, 14:48. http://cwcs.ysu.edu/resources/video/youngstown-1944.
Russell, Rita. "Paramount Project Voices IV." McDonough Museum of Art, Youngstown, OH. https://www.youtube.com/watch?v=dMnW2jApZrw.

BIBLIOGRAPHY

Oral Histories

Blakeny, Isadore. Interview by Michael Beverly, April 29, 1999. Transcript. African American Migration to Youngstown Project, O.H. 1921. Youngstown State University Oral History Program, Youngstown, OH.

Carney, Charles J. Interview by Philip Bracy, May 19, 1982. Transcript. Sheet & Tube Shutdown, O.H. 139. Youngstown State University Oral History Program, Youngstown, OH.

Carter, Romeila. Interview by Joseph Drobney, November 4, 1985. Transcript. Westlake Terrace Project, O.H. 868. Youngstown State University Oral History Program, Youngstown, OH.

Ciarniello, Dominic. Interview by Annette D. Mills, April 25, 1976. Transcript. Life in Smoky Hollow, O.H. 189. Youngstown State University Oral History Program, Youngstown, OH.

Horvatt, Robert. Interview by Mary Kay Schultz, March 4, 1981. Transcript. History of Industry in Youngstown Project, O.H. 1020. Youngstown State University Oral History Program, Youngstown, OH.

Hynes, Jack. Interview by Carol Shaffer Mills, January 26, February 3 and June 11, 1982. Transcript. Theater People from Ohio, O.H. 1579. Youngstown State University Oral History Program, Youngstown, OH.

Lottier, James. Interview by Jeffery Collier, September 5, 1975. Transcript. Youngstown YMCA Project, O.H. 388. Youngstown State University Oral History Program, Youngstown, OH.

Manning, Edward C. Interview by D. Scott Van Horn, May 14, 1986. Transcript. Youngstown in the 1920s and 1930s, O.H. 666. Youngstown State University Oral History Program, Youngstown, OH.

Meub, Walter. Interview by Janice Cafaro, August 25, 1986. Transcript. History of Industry in Youngstown Project, O.H. 489. Youngstown State University Oral History Program, Youngstown, OH.

Mills, Gale. Interview by Annette Mills, June 3, 1976. Transcript. Life in Smoky Hollow, O.H. 400. Youngstown State University Oral History Program, Youngstown, OH.

Ross, Fred, and Josephine Ross. Interview by Thomas Welsh, April 9, 2010. Transcript. Steel Valley Voices, YSU Center for Working Class Studies, Youngstown State University, Youngstown, OH.

Sapio, Antonetta Mary Julian. Interview by Molly A. McNamara, July 25, 1988. Transcript. Ethnic Groups of Youngstown, O.H. 1189. Youngstown State University Oral History Program, Youngstown, OH.

BIBLIOGRAPHY

Publications of Government Departments and Agencies

National Housing Association. *Proceedings of the Sixth National Conference on Housing, Report from the Secretary*. Chicago, IL, 1917.

State and Local Government Documents

Youngstown Metropolitan Housing Authority. *Postwar Improvements Proposed Program of Public Housing for Low-Income Families in Youngstown*. Youngstown, OH, 1945.

Unpublished Sources

Karas, Richard Milan. "Caldwell History." Youngstown Public Library, Youngstown, 1935.

Sharo, Joseph J. "Monkey's Nest: A Look Back at Life in Youngstown During the 1930s." Youngstown, 1999.

Visual Sources

Ohio History Collection. "Youngstown Sheet and Tube Architectural Rendering." 1915. Ohio Memory Collection, caption. http://www.ohiomemory.org/cdm/ref/collection/p267401coll36/id/25086.

Websites

Ramos, Steve. "A Father's Tale." All Things Youngstown. http://www.allthingsyoungstown.net/articles/a_fathers_tale.htm.

Ruminski, Clayton. "Death, Technology, and the Rise of Steel." That Devil History, January 17, 2014. https://thatdevilhistory.wordpress.com/tag/youngstown-sheet-and-tube.

Schenold, Bill. "Interview with Dick Biondi," WCFL. http://web.archive.org/web/20030812235549/www.manteno.com/wcfl/biondi.html.

Vergara, Camilo José. "About this Project." Tracking Time. http://www.camilojosevergara.com.

INDEX

A

Aeroquip Corporation 48, 49
Allen, Martel Davis 106
Andrews, Bill 77, 78
Attenberger, Donald 98

B

Bancroft, Kelly 120
Banks, Rebecca 151
Basie, Count 104, 132
Bell, Boots 109, 110
Belmont Theater 94, 117, 118
Bennett, Tony 133
Bethlehem Steel 24, 25, 28, 30, 34
Bigelow, Robert 109
Biondi, Dick 107
Black and Tan Club 133, 134
Black Monday 13
Blackwell, Richard 77
Blakeny, Isadore 133
Bott, Raymond 99, 100
Brier Hill 15, 19, 125, 131, 136, 137, 140, 143, 145, 147
Brier Hill Italian Fest 144
Brier Hill Steel Company 24, 44
Brier Hill Works 35, 37, 38, 144
Brown, James 99, 106
Butler School 130

C

Caldwell District. *See* Monkey's Nest
Caldwell, John 126
Cameo Theater 66
Campbell, James 20, 24, 25, 26
Campbell Works 19, 20, 28, 31, 35, 36, 37, 50, 51, 52
Carnegie Steel 44, 130
Carney, Charles 101
Carter, Romelia 103
Cassese, Carmine L. 152
Cassese, Carmine T. 152
Cassese, Joseph J. 153
Cavalier, L.A. "Tony" 102, 104, 106, 112
Cave Lounge, the 89
Chrystal, Jeffrey 97
Ciarniello, Dominic 147, 148, 153

INDEX

Cicero's 84, 86
Civil War 20
Collins, Maureen 96
Colonial House 13, 80, 82, 86, 96, 98
Corcoran, Sister Jerome 100
Cotton Club 133, 134
Crane, C. Howard 13, 63

D

DeBartolo, Edward 145
DeCicco, Bill 119
Deibel, C.W. 61, 65
Dejulio, Al 110
Del Rays 110, 111
DeNiro, Vince 84, 86
Dill, Bruce 111
DiPasqua, Guy 150
Dome Theater 63

E

East Youngstown 20, 22, 23, 25, 41, 42, 43
Easy Street Productions 96, 122
Economou, Irene 150
Ecumenical Coalition 35, 36, 37
Edsels, the 107
Elms Ballroom 13, 15, 99, 101, 106, 109, 111, 112, 133
Excelsior Theater 60, 61

F

Fetchet, Frank 84
Fitzgerald, Ella 104, 133
Ford, Henry 29, 44
Forest Glen 116, 121
Foster, Stephen 94
Foster Theater 70, 95, 115, 120, 122
Fox Theater 117, 139, 140
Freed, Alan 105

G

General Fireproofing 39, 42, 44, 147
George, Bill 149
Glossbrenner, A.S. 32
Grand Opera House 60, 63, 70

H

Halfacre, Frankie 106
Hancock, Todd 96
Handel's Ice Cream 116
Hanni, Don, III 110
Harrison Field 148, 153
Hartman, Elizabeth 75
Hippodrome Theater 63
Home Theater 117
Horvatt, Robert 34
Hotel Pick-Ohio 102
Human Beingz 92, 111
Hunter, William 137
Hynes, Jack 65, 70, 75

I

Idora Ballroom 32, 102, 107, 109, 112, 113
Idora Park 23, 41, 64, 81, 109
Ink Spots 104, 133
Inland Steel 24
Isaly's 98, 139, 143

J

Jacobs, Bob 72
John Chase Pool 136
Jones and Laughlin Steel 37
Jones, Nate 106

K

Kay, Johnny 109
Keith-Albee 13, 66
Kerrigan, Patrick 82, 88
King, Clarence 103, 107, 112

170

INDEX

Kirwan, Michael 31, 33, 135
Kool and the Gang 106
Korean War 19, 30
Kosa, Victor 84
Kovalchik, Bill 129
Krakusy Hall 102
Kretzer, Alan 82
Kyle's Corners 82

L

Lambeth, Jennings R. 35
Lariccia, Ben 145, 150
Lee Tire and Rubber 44
Lewardo's 89
Liberty Theater 13, 59, 61, 63
Little Steel Strike 27
Lottier, James 135
LTV Corporation 37
Lykes Corporation 34

M

Mahoning Theater 117
Mahoning Valley Economic Development Committee 36
Manning, Edward 66
Mansion, the 84, 97
Mansion, the (dance venue) 102
Market Street Theater 93
Markulin, Joe "Ting" 93, 111
Martin, Tonya 77
McGovern, Maureen 92
Meshel, Honorable Harry 104, 134
Meub, Walter 34
Mickey's Bar 90
Mills, Gale 147, 154
Modern Homes Company 149
Monkey's Nest 13, 15, 125, 127, 131, 136, 139, 140, 143, 145
Moore, James 77, 120
Moore, Liz 106

Mr. Wheeler's 80, 86, 87, 96, 98
MVR 150, 152
Mystic Knights 103

N

New Bethel Baptist Church 132
New Mock Theater 117
Newport Theater 15, 73, 114, 116, 118, 120, 121
Nu Elms Ballroom. *See* Elms Ballroom

O

Oak Park 149, 150
Ohio Leather Company 39, 44
Ohio Theater 115
Orpheum Theater 64, 66
Our Lady of Mount Carmel Church 146
Oven, the 96, 98

P

Pacic, Edo 128
Palace Theater 75, 79, 117
Palace Theater (Campbell) 117
Palace Theater (Hubbard) 117
Paramount Pictures 66
Paramount Project 79
Paramount Theater 13, 15, 59, 66, 71, 75, 77, 79, 118
Parella, Robert 96
Parker, Nadine 135, 136
Park Theater 64, 70
Peyko, Mark 63
Pillot, Jeff 120
Poindexter, Jerry 106
Posey, Fred 117
Puullas, Elaine 93
Princess Theater 64
Purnell, Frank 26

INDEX

Q

Quaranta, Edward 90
Quaranta, Jerry 90
Quaranta, Leander 89
Quaranta, Ron 89

R

Raful, Joseph 115
Raful, Paul 114, 115
Ramos, Steve 144
Ramos, Tom 139
Rango, Carl 84, 97
Reed's Arena 112
Regent Theater 64
Republic Hose 51, 52, 55
Republic Rubber 12, 15, 39, 40, 44, 45, 48, 49, 50, 51, 55, 147
Republic Steel 12, 25, 27
Reuter, Cathy 87
Rialto Theater 93
Richley, J. Philip 35, 51, 142
Ridder, Patrick 151
Ridel, John 97
Roncone, Mike 107, 111
Roosevelt, Eleanor 11, 135
Rosselli, Dominic 148
Ross, Josephine 141
Rotundo, Joe 90
Rudjak, Father Joseph 143
Ruminski, Clayton 21
Russell, Rita 73

S

Saints Cyril and Methodius Church 127, 146
Saints Peter and Paul Church 127
Sapio, Antionetta Mary Julian 141
Scarsella, Richard 94, 96, 121
Schenley Theater 94

Sears 87
Shagrin, Joe 70
Sharo, Joseph 129
Sharon Steel 12
Sinatra, Frank 13, 99, 104
Sinchak, Del 107
Singleton, Frances Prayor 139
Sky-Hi Drive-In 74, 117
Smoky Hollow 13, 15, 128, 145, 147, 153, 154
Soni, Betty Peters 110
Southside Drive-In 74
Stadler, Frank 101
St. Ann's Roman Catholic Church 137, 142
St. Anthony's Catholic Church 139, 140
State Theater 64, 66, 70, 71, 72, 75, 118, 120
St. John's Episcopal Church 153
Strand Theater 64
St. Rocco Episcopal Church 140, 142

T

Tatarka, Helen 131, 140, 144
Thomas, Gerryanne 91
Traficant, James 33, 54
Truman, Harry 13, 19
Truscon Steel 44

U

Umbel, William 98
Uptown 13, 15, 80, 82, 84, 87, 90, 93, 97, 98, 115
Uptown Theater 80, 93, 96, 98, 115, 117, 120, 122
urban renewal 13, 112, 143, 150
U.S. Steel 12, 25, 27, 28, 52, 125

INDEX

V

Vallourec Star 38
Van Sickle, Robert H. 97
Vargo, Bob 117, 119
vaudeville 13, 61, 63, 64, 66, 94
Vergara, Camilo José 14
Vindicator 25, 30, 31, 52, 61, 63, 76, 83, 128

W

Warner brothers 63, 67, 71
Warner Brothers (company) 70
Warner, Jack 129, 145
Warner Theater 67, 71, 75, 118
Wellman, Peter 94, 117, 119, 120
Wellman Theater 117
West Federal Street YMCA 134
Westlake Crossing 125, 128, 131, 144
Westlake Terrace 135, 136, 142
Wheeler, Ralph 86
Wick Neighbors 153
World War II 13, 34, 39, 46, 82, 148, 150

Y

Yankee Lake Ballroom 101
Youngstown Sheet and Tube 12, 13, 15, 19, 20, 21, 22, 23, 25, 26, 27, 28, 34, 37, 38, 41, 42, 43, 50, 78, 147
Youngstown State University 14, 99, 113, 152
Youngstown University 112

Z

Zellers, Rob 87, 145

ABOUT THE AUTHOR

Sean T. Posey is a freelance writer, photographer and historian. He holds a bachelor's degree in photojournalism from the Academy of Art University in San Francisco and a master's degree in history from Youngstown State University. His work has been featured in a wide variety of publications, including the *San Francisco Chronicle*, *CityLab* and *San Francisco Magazine*. Sean's work is currently featured in the books *Car Bombs to Cookie Tables: The Youngstown Anthology* and *The Pittsburgh Anthology*, both by Belt Publishing.

Visit us at
www.historypress.net

This title is also available as an e-book